WITHDRAWN
FROM THE RECORDS OF THE
MID-CONTINENT PUBLIC LIBRARY

D0940075

PRINT
COLLECTIVE

a a a a a a
a a a a a a a a a a
a a a

Mid-Continent Public Library
15616 East US Highway 24
Independence, MO 64050

An Imprint of Sterling Publishing
387 Park Avenue South
New York, NY 10016

Text and Photography © 2013 by Jenny Doh

All rights reserved. No part of this publication may be reproduced, stored in a retrieval system,
or transmitted, in any form or by any means, electronic, mechanical, photocopying, recording,
or otherwise, without prior written permission from the publisher.

ISBN 978-1-4547-0754-7

Library of Congress Cataloging-in-Publication Data

Doh, Jenny.
 Print collective / Jenny Doh. -- First Edition.
 pages cm
 Includes index.
 1. Prints--Technique. I. Title.
 NE860.D64 2013
 760.28--dc23
 2013000604

Distributed in Canada by Sterling Publishing
c/o Canadian Manda Group, 165 Dufferin Street
Toronto, Ontario, Canada M6K 3H6
Distributed in the United Kingdom by GMC Distribution Services
Castle Place, 166 High Street, Lewes, East Sussex, England BN7 1XU
Distributed in Australia by Capricorn Link (Australia) Pty. Ltd.
P.O. Box 704, Windsor, NSW 2756, Australia

For information about custom editions, special sales, and premium and corporate purchases,
please contact Sterling Special Sales at 800-805-5489 or specialsales@sterlingpublishing.com.

Email academic@larkbooks.com for information about desk and examination copies.
The complete policy can be found at larkcrafts.com.

Every effort has been made to ensure that all the information in this book is accurate. However, due
to differing conditions, tools, and individual skills, the publisher cannot be responsible for any injuries,
losses, and other damages that may result from the use of the information in this book.

Manufactured in China

2 4 6 8 10 9 7 5 3 1

larkcrafts.com

MID-CONTINENT PUBLIC LIBRARY - QU

3 0003 13248292 6

PRINT
COLLECTIVE

Screenprinting
Techniques & Projects

FEATURING: **Hilary Williams, AntiGraphic, Little Korboose, Kat Jackson, Mama's Sauce, Yuriko Iga, Bombina Studios, Amy Fierro, Matt Shapoff,** AND **Ruth Bleakley**

JENNY DOH

LARK

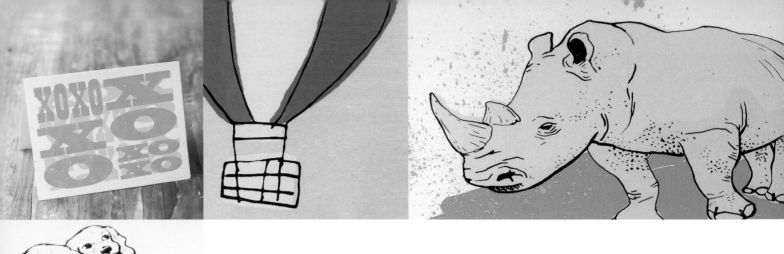

CONTENTS

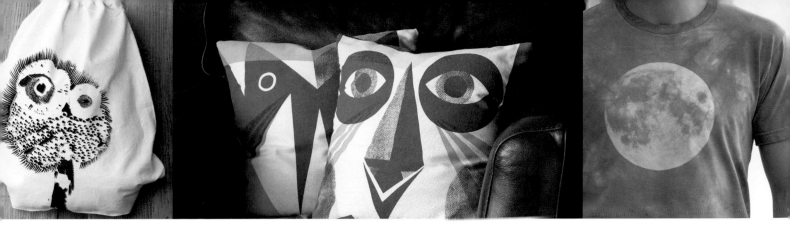

It's an exciting time to be a printmaker. If you want to dabble, you can gather a few basic supplies and create relatively simple designs at the kitchen table (just don't use the same spoons for ink and food!). If you want to dive deep and print large print runs of complex designs, setting up a home studio is easier and more affordable than ever. In some cities, screenprinters have even banded together and started communal studios you can join.

INTRODUCTION

That's where *Print Collective* comes in. It brings together a community of artists who exemplify the broad spectrum of screenprinting. Just like dropping into a local studio, you will learn from their unique points of view, become inspired by their aesthetics, and benefit from their expert tips.

While most of the featured artists are screenprinters, this book also includes two artists who make prints in alternative ways—what studio is complete without artists that go off the beaten path? Matt Shapoff of Handmade on Peconic Bay is a master of cyanotype printing. And Ruth Bleakley is passionate about relief printing. She demonstrates three types, using bubbles, Styrofoam, and seashells.

But the core of the book is screenprinting. So start with the basics and then visit the sections or projects that call to you. The Resources section (page 142) will help you locate any supplies you need. And don't forget to check out the motifs on the enclosed CD. The artists included many more designs than you see in their projects—and you're encouraged to mix and match!

Whether you print for a couple of hours a month or for weeks on end, whether you want to buy a bunch of screens and inks or just enough for one project, it doesn't matter. If you learn to print, you're now part of the collective.

THE BASICS

Before you jump into the guest artists' projects and techniques, chances are you will need to learn how to screenprint. Along with must-have materials and directions for setting up a home studio, in this chapter you'll find easy-to-understand instructions and helpful tips—straight from the pros.

In short, you will learn how to coat screens with emulsion, expose them to UV light, and pull ink through them onto paper, fabric, or another substrate. That sounds intense! But you'll quickly see that while there are many unfamiliar words and processes, screenprinting is not hard once you get started. Just like any other craft, repetition is the key to success. Practice makes perfect (or intentionally imperfect).

BEFORE YOU BEGIN

Studio Set-up

Some prints require only a few common tools and a small space, while others rely on specialized (but easily acquired) supplies and more space to achieve the desired effect. As you look over the projects you want to try, consider what they have in common. If you think there's even one project where you might want a larger screen, buy the larger screen! It's always better to have a little more growing room than you need, especially if you can easily use it for other projects.

Whether you're printing in the living room, basement, or an actual studio, read through the Studio Essentials section on this page for a list of supplies you'll need. These tools will be used in just about every project in this book, so be sure to have them ready before you start. As we discuss specific methods, you will find additional tool kits specific to each process. The Screenprinting Tool Kit (page 16) is the one we'll use in about 75 percent of the projects, but we've also tried to make it easy to figure out what you need for other methods of printing (starting on page 28).

The Screenprinting Tool Kit (page 16)

STUDIO ESSENTIALS

Cloth rags (for general clean-up)

Craft knife

Masking tape

Paintbrushes suitable for printmaking paints and inks in assorted sizes

- small for detail work
- medium for basic applications
- large for heavy coverage

Pencil

Pen and/or marker

Ruler

Scissors

Transparent tape

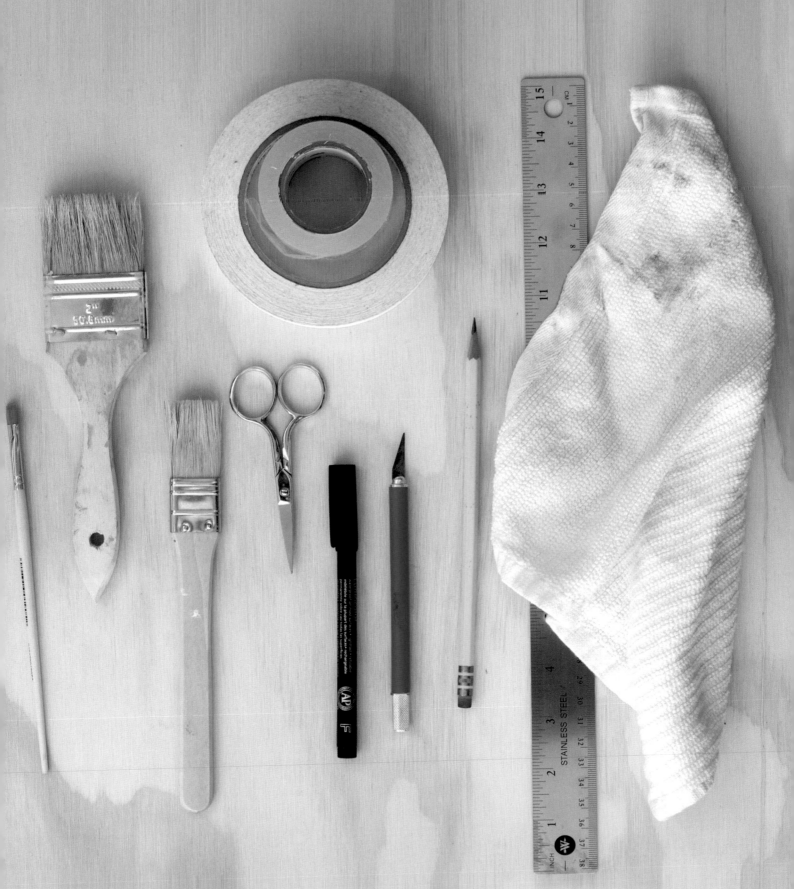

Surfaces and Inks for Printing

Regardless of the specific printing method and the project you have in mind, you always need something to print on—your printing surface (also known as the substrate)—and something to print with, usually a form of ink. Though technically you can print on anything you'd like, some surfaces are more common and easier to work with than others.

PAPER

A beautifully printed image on paper is hard to beat, but paper doesn't hide any mistakes either (unlike fabric, which is a little more forgiving). To achieve the best results when working with paper, lean toward heavyweight paper, at least 80 lb. weight or cardstock. The heavier the paper, the more likely it is to stay in place while you're printing on it. If you plan to do a really ink-heavy design but want to use thinner paper, or if you plan to do some cyanotype printing, watercolor paper is the way to go. It's designed to work well with moisture. This is more important for cyanotype than it is for screenprinting because the paper you use has to absorb the chemicals and stay wet long enough to allow for the lengthy sun exposure that is sometimes necessary.

Smooth wood, paper, and fabric are popular printing surfaces.

FABRIC

Fabric is a very common substrate for screenprinting, as it allows for a bit more flexibility in design. You can dye the fabric before you screenprint it, as Amy Fierro shows you on page 89, or you can print directly onto plain fabric, as Yuriko Iga does on her tote (page 70). When working with fabric, be sure to use textile-appropriate ink, and cure the design to ensure it doesn't fade when washed (see Curing a Fabric Print, page 25). If you'd rather not buy fabric-specific screenprinting ink, you can experiment with adding ink retarder to your basic screenprinting ink, like Kat Jackson teaches on pages 110–113. Ink retarder will thin the ink to make it behave more like fabric-appropriate ink.

WOOD

Birch and maple tend to be good, smooth woods for printing. However, if you'd like to try your hand at printing onto wood, any smooth wood should work as long as it's not coated with a waterproof sealant. You can find wood at a lumberyard or home improvement store, and most locations will even cut it to size for you. If you have a found piece of wood, you can sand down the rough spots and give it a try. You can also try to print on secondhand wood furniture. Some finishes will readily accept ink, but others will need a lot of sanding. As a test, try dabbing a little bit of ink on the back of the piece and see what happens.

WATER-BASED SCREENPRINTING INK

The majority of the artists featured in this book use water-based screenprinting inks in their projects. (Oil-based inks and paints are often used in industrial environments, but water-based varieties are better suited for home and small studio use.) Water-based screenprinting inks can be cleaned up easily with soap and water, generally require less effort to cure than oil-based inks, and come in regular and textile varieties.

Many hobby outlets sell screenprinting inks, including varieties by Speedball and Jacquard. Professional-grade screenprinting inks can be purchased online (and are often worth the marginal difference in cost). There are also a number of "special-effect" screenprinting inks that can be used to add interest to projects, including glow-in-the-dark and UV-reactive inks, as well as textured inks that simulate suede or have a "wet look." Once you're comfortable using basic inks, order something fun!

Water-based screenprinting inks can be safely stored for months by keeping them tightly sealed in the manufacturer's original packaging. If you want to store mixed inks, do so in dark, airtight containers following the storage instructions provided by the manufacturer. Most water-based inks will air-dry if left exposed, but oil-based inks can often be left open for days, weeks, or longer without drying out (which is why they tend to be used in high-volume print shops).

Water-based screenprinting inks will last for months when stored in airtight containers.

OTHER INKS AND PAINTS

Ruth Bleakley (page 120) uses block-printing ink in her relief-printing projects. It's slightly thicker and tackier than screenprinting ink, making it easier to work with when using found objects. Speedball offers a quick-drying water-soluble block-printing ink that is widely available and provides good, consistent results.

Liquid acrylic paint and spray paint are also good options to have on hand for printing (when you're not using a screen). Cost-effective and easy to use, they both work especially well with stencils. Liquid acrylic paints will adhere to a wide array of surfaces, including fabric when mixed with a textile medium such as Liquitex Fabric Medium. Spray paint is one of the most effective ways to apply an even coat of color—which you may want to do on a surface before you screenprint. Because spray paint can't be mixed like the other inks, you won't be able to create your own custom colors, but the color palette offered by manufactuers is growing daily. If your local hardware or home improvement store carries only a limited selection, try looking online to find additional color options. Spray paint comes in multiple finishes (including gloss, satin, and matte) as well as specialty varieties, such as metallic and faux stone. Note that the textured varieties may be tough to print on top of, but they can also add textural interest to a simple print.

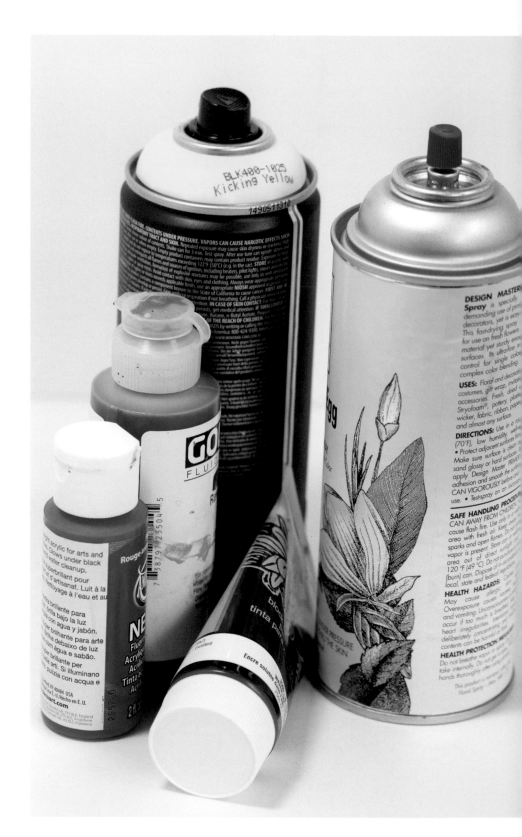

Screenprinting ink (top) can be mixed with a transparent extender base to make it less opaque (bottom).

Experimenting with Color

Instead of investing in a whole rainbow of ink and paint colors, you can stretch your budget by purchasing only five basic hues—red, blue, yellow, black, and white—and mixing your own. A color wheel can serve as a helpful starting point for creating your own custom colors, but spending time mixing your colorants together will ultimately give you the greatest sense of how the colors impact each other.

When mixing colors, begin with your base hue and add only a small amount of the other desired colors. After mixing thoroughly, you can continue adjusting the tone by adding more of any of the colors until you find a suitable shade. It is much easier (and less wasteful) to make small adjustments to hues instead of mixing large globs together hoping for the right combination. Use ratios by spoonful or by weight and keep track of the

"recipes" for the colors you make, so you can accurately replicate them in the future. And remember that ratios will likely change if you switch brands, so note what brand you're using as well.

Another exciting way to play with color is to experiment with a transparent extender base like the one by Speedball, or clear screenprinting ink. Because so much of screenprinting is done in layers, it can be fun to have some of the layers appear more opaque than others. Anneke Kleine-Brüggeney relies on transparent extender base when creating her pillows (page 78), and Nick Sambrato (page 34) loves to use clear ink in his projects to allow the layers to interact with each other in a way they may not be able to as fully opaque inks. Similar to mixing colors, it is best to add a little at a time until you reach the desired transparency.

SCREENPRINTING

Getting Started

Oh, the possibilities! Screenprinting is one of the best ways to reproduce intricate, colorful designs on just about any flat surface. While screenprinting can be used for projects on a wide variety of substrates, including paper, fabric, and wood, much of the process remains the same. Read through the Screenprinting Tool Kit (page 16) for a list of supplies specific to this method.

Once screens are dry and not in use, they can be stored on shelves for easy access.

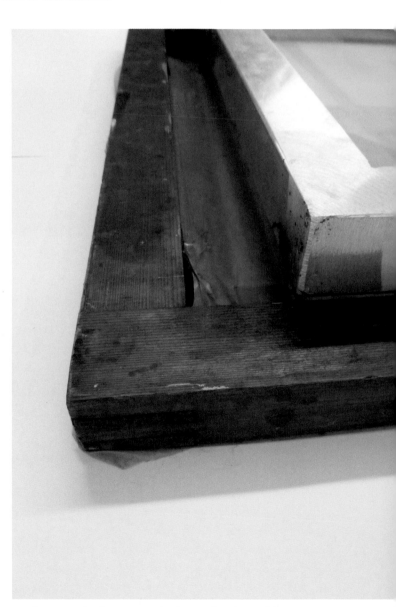

Pre-stretched screens in both wood and metal frames.

BUYING SCREENS

Pre-stretched screens are sold through screenprinting supply companies and some hobby stores (see Resources, page 142). These screens come tensioned and assembled for immediate use. Pre-stretched screens are available in a variety of dimensions and mesh sizes for printing applications of all types.

For most of the projects in this book, you will use one or both of the following size screens: the standard frame size, 20 x 24 inches (50.8 x 61 cm), and a smaller frame size, 10 x 14 inches (25.4 x 35.6 cm). Many of the projects have designs that are much smaller than these screens, so you'll be able to burn multiple layers onto one screen by leaving a small gap between each image. When printing, use the same low-adhesive tape that you use to seal the edges of the screen to cover the areas that you do not want to print (the tape is placed on top of the design, not beneath it). Remove the tape immediately after use to prevent adhesive residue from filling the holes of the mesh.

The mesh size will affect what you print, so check the specs on your screen. Look for a number that indicates the number of threads per square inch—simply put, the larger the number, the smaller the opening and the tighter the mesh. Why is that important? Meshes with tighter counts (like 200–230) retain greater detail, making them necessary for projects that require precision and clarity. Mesh size can also affect how your ink passes through the screen. Inks that are especially thick or contain large particles (such as some special-effect inks) may not be able to pass through the small holes of a tight mesh; on the other hand, using thin inks with a lower mesh count can lead to blurriness in your prints. Mesh counts of 110 and 156 work well for most projects in this book if you print with standard inks.

ALUMINUM V. WOOD FRAMES

Wood frames are preferred by many screenprinters because they are generally less expensive than aluminum frames. However, one common criticism that screenprinters have of wood frames is that after several uses, the wood frames have a tendency to warp, while aluminum frames do not. Both types of frames are available at screenprinting supply stores. Considering the short-term and long-term budget limitations that you have for your screenprinting needs may ultimately help you decide which frames to get.

PREPARING SCREENS

To ensure that your emulsion fluid will properly cure to the mesh of your screen, you will need to degrease your screen prior to coating. Degreasing removes any dirt, oils, or other residues from the mesh and helps to eliminate pin-holes and other common coating issues. Here's what you do:

1. Rinse both sides of your screen with water. A pressure washer will provide the best results, but a garden hose with an adjustable spray nozzle will also work.

2. Pour your degreasing solution into a spray bottle and spray a small amount onto the surface of your screen.

3. Thoroughly scrub the mesh on both sides of the screen, using a scrubbing pad. Work either from top to bottom or from side to side.

4. Rinse the solution off of your screen using moderate pressure, starting from the top and working downward, sweeping from side to side.

5. Flip the screen so that the bottom edge becomes the top edge and rinse again. Continue rinsing and flipping the screen until the water runs clear and the mesh is free from residue.

6. Allow the screen to dry completely in a clean, dust-free area. *Note*: You can speed up the drying process by using a hair dryer. If you use a hair dryer, choose a low-heat setting and avoid getting too close to the screen, as heat can damage the mesh.

SCREENPRINTING TOOL KIT

Pre-stretched screen

Screen degreasing solution

Spray bottle

Scrubbing pads

Pressure washer or garden hose with a strong nozzle

Exposure unit (see page 17)

Photo-sensitive emulsion

Light-safe yellow bulb

Scoop-coater (see page 18)

Transparency film (also called acetate)

T-square

Transparent tape

Low-adhesive screen tape (or clear packing tape)

Squeegee

Spray adhesive

Ink scoop

Water-based screenprinting inks

Iron or heat press

Teflon-coated sheet

Illustration board

Screenprinting press (see page 26)

Emulsion remover

Dust mask

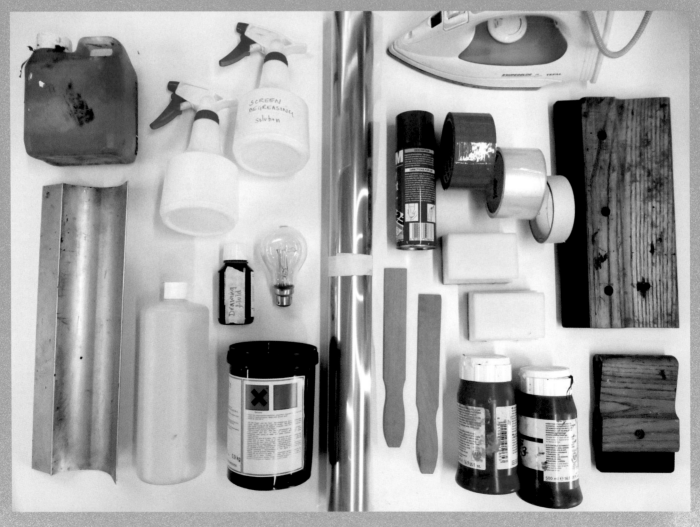

SETTING UP AN EXPOSURE UNIT

Affordable exposure units can be set up in many different ways: with the light traveling upward (as shown below), downward, or horizontally. Whether you custom-build one with wood or make do with shelving units or boxes, the basic concept of an exposure unit can help you plan your own:

➼ For a unit with light traveling upward, you will need a UV-light source that can be secured on the ground, at the bottom of a box or cart, or on the lower shelf of a shelving unit. Note: A 500-watt halogen bulb is a good place to start. You may want to try higher-watt bulbs as you experiment with exposure times.

➼ Secure a piece of glass approximately 12 to 17 inches (30.5 to 43.2 cm) away from the light source. The glass needs to be clear with no coating of any kind, and ¼ inch (.64 cm) thick.

The following items can then be placed onto the glass in this order:

➼ transparency film with printed artwork registered and taped to the screen coated with emulsion

➼ piece of fabric slightly larger than the screen

➼ large piece of foam that can fit within the screen's frame

➼ heavy books or bricks (or other items with weight)

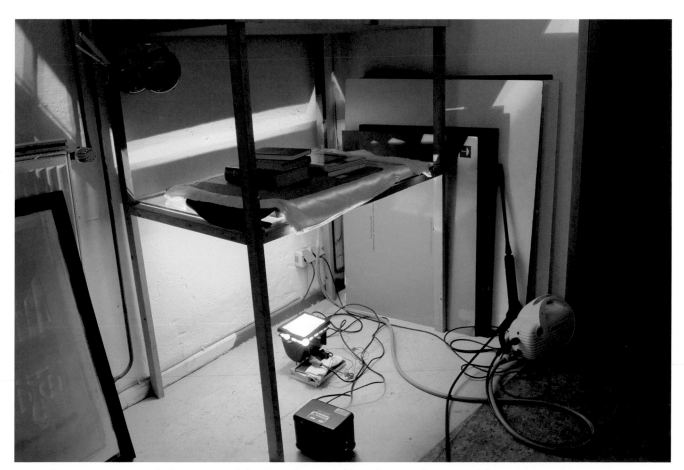

In this exposure unit, a light source stabilized on the ground travels upward to expose the print onto the screen.

Transferring Your Design to the Screen

COATING THE SCREEN WITH EMULSION

Using photo-sensitive emulsion is the best way to capture fine details and patterns, but it requires some practice to achieve perfection. The recipe for success with emulsion has three ingredients: a thin, even coat of emulsion on the screen; the proper exposure time and settings; and an effective post-exposure rinse-out. Because the emulsion is UV-reactive, the following steps should be done in a dark room under a yellow bulb:

1. Mix the emulsion solution, following the manufacturer's instructions.

2. Load your scoop-coater with emulsion so that it is approximately three-quarters full.

3. Lean your dry, degreased screen against a wall or other flat surface as close to upright as possible, with the back side of the screen (the side on which the mesh is flush against the frame) facing you.

4. Hold the scoop-coater level with your hands at the bottom. Firmly press the lip of the scoop-coater against the bottom of the screen and angle it slightly so that the emulsion comes in contact with the mesh. Pull the scoop-coater up to the top of the screen, then quickly tilt it back to prevent excess emulsion from pouring out.

5. Flip the screen over so that the inside is facing out. Apply a layer of emulsion on the inside, using the same technique described above. Since this coat will form the surface that you pull ink along when making your print, it is important that it is smooth and free of streaks, ridges, and drips.

6. Allow the screen to dry completely.

This screen is evenly coated with emulsion.

This screen has a lumpy and uneven coating of emulsion.

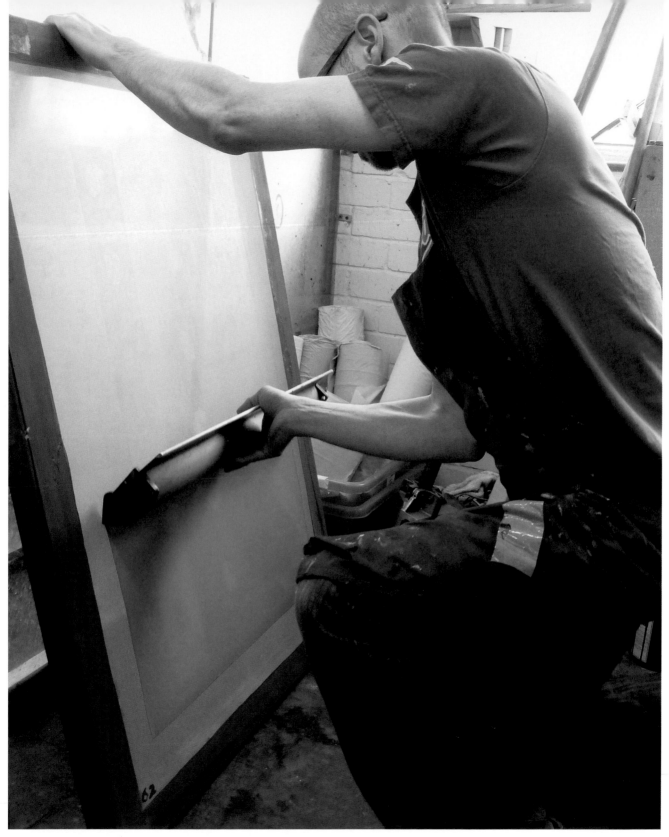

As the scoop-coater is pulled from the bottom of the screen to the top, excess emulsion will remain in the scoop-coater. Once you reach the top, the excess can then be poured back into the emulsion container for later use.

COMPOSING A DESIGN

Before you proceed, you should choose a design. On the accompanying CD, the contributing artists in *Print Collective* have shared some of their favorite design motifs to help you get started. Some of these motifs are the exact ones that they use in the featured projects, some are variations, and some are not shown in the book at all—they're just for your projects. The motifs featured in the book are true to size on the CD. As the artist, it is up to you to size the motif to your specific project using a photo-editing program such as Photoshop, or by printing it out on printer paper and using a copy machine with enlargement and reduction settings. For example, if you'd like to make a card but with a motif that's being used on a poster in this book, then you'll need to make the motif smaller in a photo-editing program. Keep in mind that enlarging a motif to fit your specific project may result in a blurry, low-resolution image, so this is not recommended.

You can also expand your library of motifs by creating your own unique designs. The provided motifs are just a stepping-stone. In her projects, Hilary Williams (page 54) shows how she often uses a dip pen and India ink to draw directly onto transparency film, so feel free to follow her lead and create your own design directly on film. You can also create an image in Photoshop using a photograph or your own artwork, like Amy Fierro does when she edits a high-resolution photograph of the moon to create the unique T-shirt design on page 92.

PREPARING YOUR ARTWORK FOR PRINTING

Whatever motif you choose, print your design onto transparency film in black, making the print as opaque as possible. If your design measures larger than 8½ x 11 inches (21.6 x 27.9 cm), such as the pillows Anneke Kleine-Brüggeney is going to teach you how to make on page 78, print the design onto several sheets of transparency film by using the tile print mode in Photoshop, and then connect them with clear packing tape. For those who do not have Photoshop, several online tools allow you to print multiple "tiles" for a large design (one of the most popular is http://rasterbator.net/).

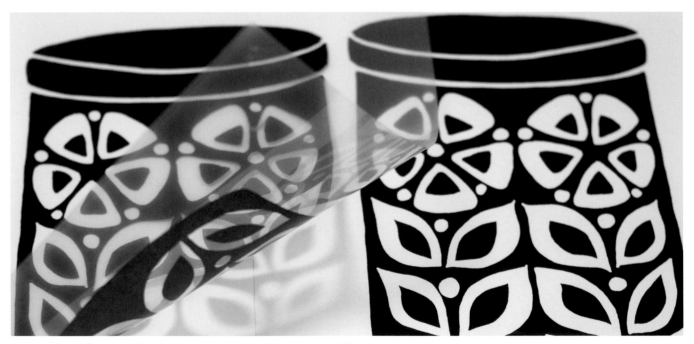

Motifs can be printed or drawn onto a piece of transparency film.

Note: Depending on the quality of your home printer, you may find that you get better opacity by paying to have your transparency printed at a print shop. The shop can increase the amount of toner used in making a print, so be sure to explain that you want your print to be as dark as possible. You can purchase transparency film in rolls for printing large designs, for a much more consistent exposure.

If your artwork involves multiple color layers, you will need to print separate pieces of transparency film for each color. Each print, or color separation, will contain only the sections of the design that will be printed in that specific color. There are exceptions. For example, Yuriko Iga actually chooses to pull several colors on one layer for many of her designs (see page 68), but for general screenprinting purposes, one piece of transparency film and one screen (or part of a screen) is used for each color.

BURNING SCREENS

Once your screen has a nice, even coat of emulsion and your design is printed on transparency film, it's time to burn your screen. To do this, you'll need an exposure unit (see page 17 for instructions on setting one up). Okay, here we go:

1. Working in a dark room under a yellow bulb, add registration marks to your screen to help you align your film. This step is especially important when working with multi-color designs, as it will allow you to consistently place each layer of the design onto each screen that you burn. An easy way to add registration marks is to use a T-square and a marker.
 ➡ Depending on the size of your design and your screen, add a mark that is a few inches down from the top of your screen, then use your T-square to extend that mark into a line that runs across the entire width. Repeat this process for each screen that will be used for your design.
 ➡ Subtract the width of your film from the width of your screen and divide that number in half. This number represents the distance from the edges of the screen that your film will need to be placed.
 ➡ Add marks on the left and right sides of the screen, and then use your T-square to extend the marks so they intersect with your top line.

2. Place your film right side up on your screen, aligning it with your registration marks. Tape the film in place with regular, transparent tape.

3. Place the glass onto the screen with the taped design so that the art is sandwiched between the screen and glass.

4. Turn on the UV-light source and expose the screen. See Testing Exposure Time on page 22 for information on determining the best exposure time for your specific set-up.

Note: An alternative to using an exposure unit is developing a system for taking the art that is sandwiched between the screen and glass out into the sunlight. You can place the "sandwich" on a cart and carefully take it outside. Allow it to stay in the sunlight for approximately 20 minutes (depending on the weather and the time of day) and then bring it inside.

Now it's time to rinse out the screen. See page 23 for instructions.

A T-square is the easiest tool to use to add registration marks to your screen.

TESTING EXPOSURE TIME

Finding the right exposure time for your screens requires a bit of trial and error. There are so many factors to consider, including light source, temperature, emulsion brand, artwork opacity, and rinse-out pressure. You will need to create some test screens in your specific set-up to determine the best exposure time. Here's an effective way to test multiple exposure times on a single screen—a technique that will save you hours (along with precious printing resources):

1. Develop a design that is a mixture of simple shapes, detailed text, and intricate halftone patterns. The finished artwork should be large enough to cover nearly the full screen with a border of approximately 2 inches (5.1 cm) on all sides. Don't be too concerned with aesthetics—this design is purely for testing purposes.

2. Use a marker and a ruler to divide your coated screen into four sections. Work in a dark room or under a yellow bulb to prevent premature exposure.

By using a piece of cardboard to control the length of time that each section of the screen is exposed, you'll be able to determine the ideal exposure time for your specific set-up.

3. Label each of the four sections with an exposure length, starting with the recommended exposure time provided by the emulsion manufacturer and working up in two-minute increments.

4. Position the screen below your light source.

5. Print the design onto a sheet of transparency film and center it on your screen, securing it in place with transparent tape.

6. Leave the first section (which is based on the manufacturer's recommended time) exposed, and cover the three remaining sections with opaque fabric or cardboard.

7. Turn on the light and allow the section to expose for the specified amount of time.

8. After the first exposure is completed, move the fabric or cardboard so that the second area can be exposed while the other three remaining sections are blocked. Expose again, but this time expose the screen for two additional minutes.

9. Repeat this process until all four sections have been exposed for different amounts of time.

10. Rinse out the screen as you normally would, wetting both sides of the screen first in order to soften the emulsion and allow it to loosen.

11. Compare the results of the four sections, looking for the exposure time with the sharpest edges and the crispest lines.

If none of the sections have the clean, precise results that you're looking for, adjust your time range and repeat the process. You may find that you need to make slight modifications in your exposure time as your bulb or emulsion ages, but this testing process will provide you with a reliable baseline for burning your screens.

RINSING OUT THE SCREEN

After your screen has been exposed, you need to wash away the unexposed sections of the design. Many studios have a rinse-out booth (a sink with three high walls to keep the water contained) and a pressure washer set at the right strength for quickly rinsing out screens. However, if you're at home, chances are you don't have a dedicated booth! The good news is that a garden hose with a strong spray nozzle attachment will do the trick. Rinsing can be done outdoors in the light, as long as you work reasonably fast and limit the amount of light in your rinsing environment until the bulk of the emulsion has been rinsed away—otherwise the light will cure the entire screen, making it tough to wash out the burned areas.

1. Rinse both sides of your screen and allow it to sit for a couple of minutes in order to soften the emulsion.

2. Spray the screen, focusing on the unexposed areas, until the emulsion begins to loosen and rinse away. To help retain crisp edges on your screen, spray primarily on the back of the screen and only rinse the printing side briefly at the very end.

3. Allow the screen to dry completely.

4. Tape off the outer edges of your screen using low-adhesive screen tape. *Note*: The scoop coater does not completely coat and seal the edges of the screen during the emulsion process. Applying this tape seals and prevents ink from passing through the edges.

If you find that the unexposed areas (your motif) are not rinsing out quickly, this is most likely a sign of over-exposure. Conversely, if exposed sections of the screen (not your motif) wash out along with the design, then you will need to wash out the entire screen using emulsion remover and start over, increasing the length of exposure.

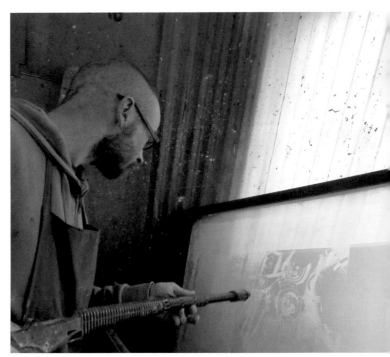

Once the screen has been burned, a pressure washer or strong garden hose will rinse away the unexposed sections.

This screen has been evenly coated with emulsion, burned, and rinsed properly.

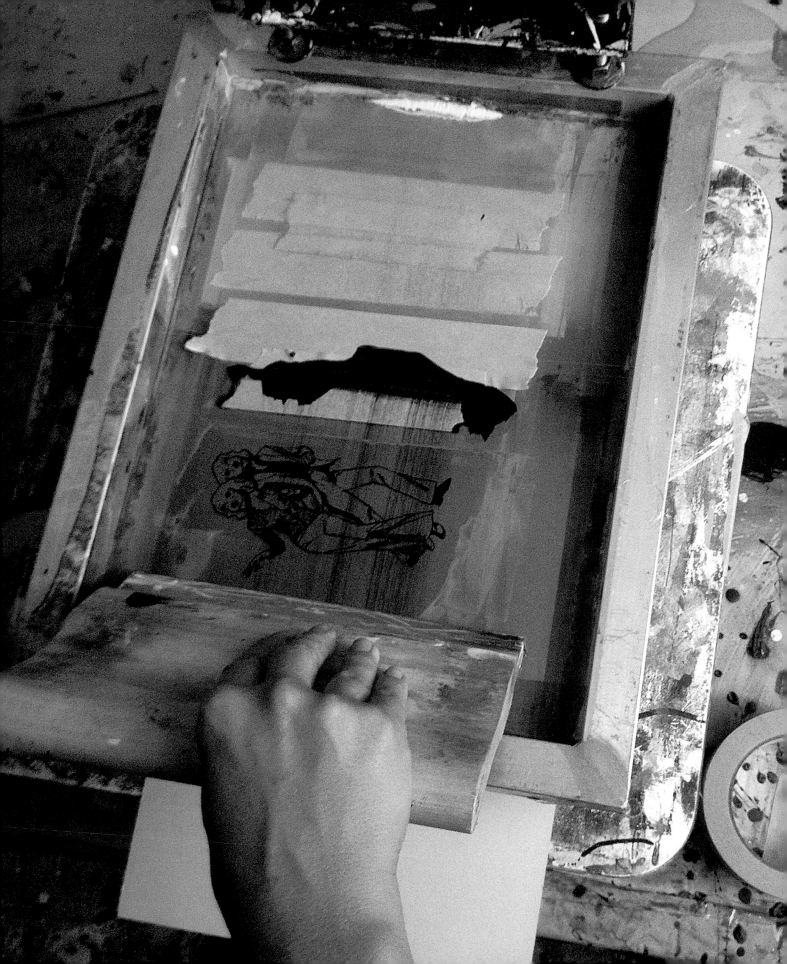

Printing

PULLING A PRINT

Now the fun really begins. You have all of the tools and skills that you need, so let's learn how to pull a print. Before you start, make sure you have plenty of material to print on and plenty of ink. If you've burned more than one layer of the design onto your screen, make sure that everything but the first layer is covered with low-adhesive screen tape or clear packing tape. After you've printed the first layer on each piece, rinse the screen, let it dry, and then re-tape it so that you can print the second layer, and so on. The set-up time is the same whether you're printing one or 100, so you should make the most of your efforts by printing as large a quantity as is practical. Let's get started:

1. Register and position the item to be printed within your screenprinting press (see page 26). If you are printing on fabric-based items, apply non-permanent spray adhesive to a platen, which is a stabilizing board used for fabrics. Insert the platen into the item and use your hands to smooth it out on the platen. Platens can be made with cardboard, cut to size.

2. Scoop a small amount of ink onto the screen, spreading it in a line immediately above your design.

3. Hold the squeegee at a 70 degree angle and pull the ink from the top of the screen to the bottom. You should stand directly over the screen so that you can apply consistent pressure as you drag your squeegee across the surface. The speed of your pull is important. Pulling too slowly can lead to blurry prints, while pulling too quickly can lead to spotty coverage. *Note*: Screenprinters hold their squeegees at different angles as a matter of personal preference. The projects in this book note different angles according to the artists' preferences. There is a bit of finesse involved in screenprinting, so adjust your technique to suit your own preferences.

4. Lift the screen and carefully retrieve your print. Move it to a drying rack or other flat surface to air-dry.

Note: Before you set up for the next print, you need to "flood" your screen. Lift up the screen away from the print surface and use your squeegee to lightly pull a

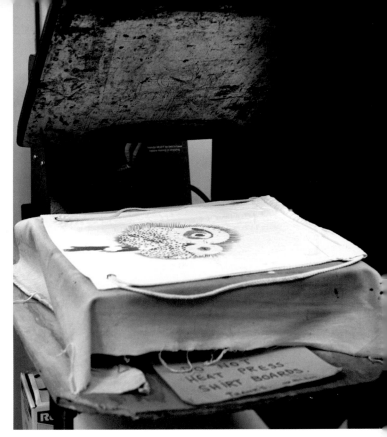

A heat press can also be used to cure screenprinted fabric.

layer of ink across the screen image (without pushing ink through to the other side). Keeping the screen completely covered with wet ink will prevent ink from drying in the open mesh of the screen between prints. When you start your next print, resume at step 3 and pull the squeegee through the flooded ink that is resting on the surface. Some printmakers will start with a flooded screen instead of a line of ink as described in step two.

CURING A FABRIC PRINT

There is nothing worse than printing an elaborate design onto a shirt or tote bag, only to have it come off in the first wash. To prevent that from happening, you need to cure your print.

1. Place your dry print on an ironing board and set a Teflon-coated sheet over the design.

2. Following the instructions provided with your ink, iron over your entire design to fuse it with the fabric.

3. Lift off the Teflon-coated sheet and set the print aside.

SCREENPRINTING PRESS AND REGISTRATION

Simply put, registration is the process of aligning layers of color within a single print, so your placement will be consistent throughout your entire print run. In order to achieve precise registration, you'll have to spend a few minutes aligning each screen on the press.

You will need a screenprinting press for precise registration. A screenprinting press can be purchased ready-made from most screenprinting supply stores (see Resources, page 142). For those who want to keep it purely DIY, there are dozens of easy-to-follow (and free) plans available for building your own (again, see Resources). If you build your own, it's still not quite free—you'll need plywood, a power drill, screws, and Jiffy hinges, along with a handful of other items—but it should only take you an afternoon to build it.

Once you have your screenprinting press and screens ready, it's time to get started:

1. Place your substrate onto the base of the press, aligning it as close to the center as possible. A substrate is any material that can be printed on, such as paper, fabric, wood, and plastic.

2. Cut two narrow strips of illustration board approximately 1 x 6 inches (2.5 x 15.2 cm) each. These will act as guides to help you position your substrate on the press.

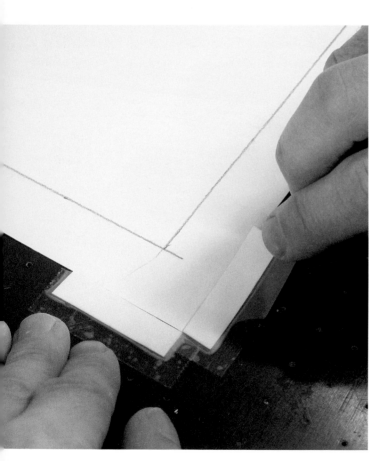

A corner made with strips of illustration board creates a guide, so that each layer of a multicolored print will be registered to the same position.

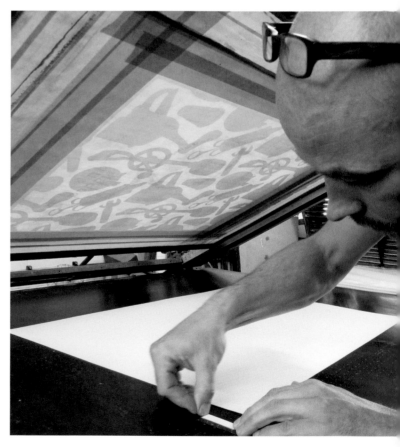

Patrick Edgeley (page 98) positions his illustration board, which will act as a guide for his printing substrate.

3. Position a strip at the corner of your substrate, and flush against the edges. Tape the strip in place.

4. Align the second strip at the same corner and along the bottom side of your substrate, making sure it is pressed along the edge. Secure the strip with tape. These two taped strips create a corner that the substrate fits into and act as stoppers so that you can press your paper or poster against the corner instead of having to guess at the proper placement.

5. Tape a printout of your finished design onto your substrate, positioning it where you want your print to appear.

6. Attach your first screen to the press, leaving it slightly loose so that you can reposition it as necessary. Using the printout as a guide, move the screen until it is aligned with the corresponding section of the design. Tighten the clamps to secure the screen in place. Clamps are built into the press (either the homemade or pre-built variety).

7. Remove the printout and attached substrate from the base of your press and set them aside. You are now ready to pull prints from the first screen, or part of a screen, in your design. *Note:* If your design is small enough that multiple layers are burned on one screen, make sure the unused layers are covered in clear packing tape.

8. After printing all of the desired copies of your first layer, remove the screen from your press.

9. Replace the reference printout and substrate on the press, then loosely attach the second screen or second part of the first screen to the clamps. Position the screen so that it is in alignment with the reference image. Tighten the clamps to secure the screen in place.

10. Repeat the process above for each color in your design.

While precise color registration is what most printers strive for, you can exercise your creative freedom and use mismatched registration to make an artistic statement. Choosing to print the layers of your design slightly askew can take a motif from basic to bold, so don't be afraid to experiment with registration in your projects.

CLEAN-UP

Taking the time to properly clean your screens and tools after each use will ensure that they last through hundreds (if not thousands) of prints. Water-based inks can be washed away with cool water and a little elbow grease. Oil-based inks require chemical solvents; refer to the cleanup instructions provided with the ink for more information.

WASHING OUT AND RECLAIMING THE SCREEN

Once you no longer need to use a screen burned with a particular design, you'll want to wash it out to remove all of the emulsion and reclaim it for a new design that you can burn onto it. Here's what you'll need to do:

1. Dampen the screen and spray emulsion remover (available at screenprinting supply stores) onto the entire screen on both sides. Allow the remover to sit on the screen for 15–20 minutes. *Note:* Do not allow the remover to stay on much longer and become dry on the screen.

2. Use a scrubbing pad to scrub the emulsion loose from the screen.

3. Wash out the screen with a pressure washer or a garden hose with a strong nozzle attachment.

OTHER PRINTMAKING TECHNIQUES

Artists who primarily rely on screenprinting still dabble in other forms of printmaking. Depending on the project or motif, it may make sense to step away from the screen. You may also find that moving from one technique to another is helpful for the creative process.

Relief Printing

Relief printing is one of the oldest forms of printing and includes everything from woodcutting and relief etching to linocutting and rubber stamping. The process starts when a design is drawn and transferred onto a material that can be cut or carved, such as wood, linoleum, or even a potato. Then the unwanted areas are removed and ink is applied to the surface of the finished block. The ink sticks only to the protruding areas and leaves the recessed areas ink-free. Finally, the ink is transferred to a piece of paper, fabric, or other substrate. For this type of relief printing, carving linoleum or rubber blocks is a good place to start, as the process requires only a few affordable supplies (see opposite page), and the resulting prints tend to be of good quality.

RELIEF PRINTING WITH A CARVED LINOLEUM BLOCK

1. Transfer your image onto the rubber or linoleum block. The easiest transfer method is to draw or trace your image with a pencil onto a piece of paper, and then place the image against the block, pencil-side down. Rub the back of the paper with a hard object such as a bone folder to transfer the image. A more precise method of transferring your image is the acetone transfer:

 ➡ Reverse your image on the computer using Photoshop.

 ➡ Print a copy of your image on a laser printer.

 ➡ Trim around the outside edge of the design, leaving a ¼-inch (6 mm) border around the image.

 ➡ Place the image face-down on the block, and use a cotton ball to apply acetone to the back of the image until it is saturated. The acetone will cause the toner to separate from the paper and transfer to the block. Lift up the paper and discard it.

2. Use a linoleum cutter to remove the unwanted portions of the block. A V-shaped blade will provide you with crisp, angled lines, while a U-shaped blade will create smooth, curved lines. Depending on the complexity of your design, you may need to alternate between various blade shapes and sizes to cut away all of the desired sections. You may also find it helpful to use a craft knife to cut some designs.

3. Spread a thin line of ink across the top of the glass plate, then roll the brayer through the ink to distribute it over the glass. Roll in one direction only until the layer of ink is thin and even.

4. Roll ink onto your carved block with your brayer, covering the design completely.

5. Place the material to be printed on top of the inked block. Press down lightly on the back of the substrate to make sure it is in complete contact with the block. *Note*: You can use the heel of your hand or even the back of a wooden spoon to rub the back of your material.

6. Carefully lift the print off the block, starting from one corner.

7. Set the print on a flat surface to dry.

8. Re-ink the stamp as necessary and continue printing.

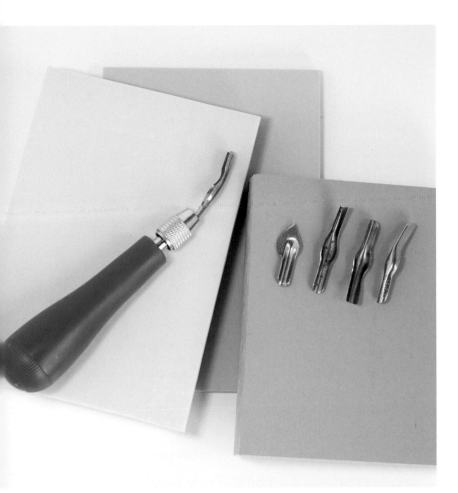

Linoleum and rubber blocks can be carved with cutting blades to make stamps that can then be inked and printed onto substrates.

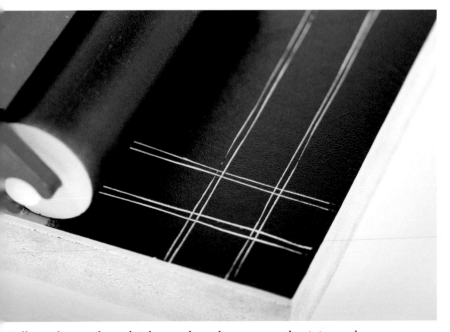

Rolling a brayer through ink on a glass plate ensures that it is evenly distributed before inking the carved linoleum block.

RELIEF-PRINTING TOOL KIT

Acetone

Cotton balls

Linoleum cutter with interchangeable tips

Craft knife (optional)

Block-printing inks

Small glass plate for inking
 Note: This can be a sheet of glass that is slightly larger than your carved block so the carved block can be thoroughly inked up.

Rubber brayer

Found objects, such as buttons, leaves, bubble wrap, corrugated cardboard, etc.

Flat, stiff surface, such as plywood, thin hardboard, matboard, or heavy-weight cardboard

Glue

Paintbrush or palette knife

Felt square to create inkpad
 Note: This is required for collography only. The felt acts as a diffuser to keep the ink from becoming a glob. You can use just about any type of felt; just make sure it is a bit larger than whatever you're trying to print.

COLLOGRAPHY

1. Glue desired found objects onto a flat, stiff surface, such as plywood, hardboard, or heavy-weight cardboard. You can layer multiple materials—including textured fabrics, leaves, feathers, buttons, string, or corrugated cardboard—to create more complex designs.

2. Allow the block to dry thoroughly.

3. Apply a few dollops of ink to your glass plate, spreading it with a paintbrush or palette knife. Set the felt square on top of the ink and push it down so it can absorb the ink. The felt will act as an inkpad, allowing you to apply ink over the surface of your block with less risk of ink pooling in the recesses.

4. Ink your glued block by pressing it into the felt pad until all surfaces are covered.

5. Press the inked block onto your substrate, applying even pressure across the back to ensure uniform contact throughout the entire design.

6. Lift your block off of the substrate. If you will only be printing the design once, set your material aside to dry. If you will be creating a repeating pattern, re-ink the plate as necessary and continue stamping.

7. Set the printed piece aside to dry thoroughly.

8. Re-ink the stamp as necessary and continue printing on other substrates.

Relief prints can be applied to paper, fabric, wood—any substrate flat enough to make adequate contact with the block. Relief printing is especially popular for printing paper goods, such as gift wrap, cards, scrapbook and journal pages, and mixed-media collages. Relief printing can also be used to create unique textiles: think tea towels, onesies, or tote bags.

In collography, found hardware pieces, like these three nuts, are first glued onto a piece of cardboard.

Once the nuts are dried on the cardboard, they are pressed onto an inkpad made from felt, much like a rubber stamp.

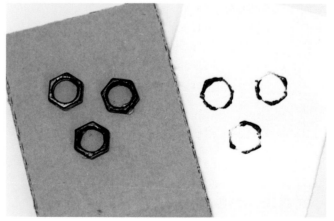

The inked block is then pressed onto the substrate, creating a unique print.

Stenciling

If you want to print repeating patterns or high-contrast designs, stenciling is your best bet. Stencils can be made from almost any flat material that is thick enough to be cut without tearing, such as cardboard or acetate. Although cutting an ornate design takes a bit of skill and patience, stencils are easily stored and can be reused many times over. Unlike most of the other printing methods that have been discussed, stenciling can even be done on three-dimensional surfaces.

MAKING A STENCIL

The first (and most important) step in creating a stencil is the planning phase. Not every design is suitable for stenciling. Graphics that have extremely fine details, gradients or halftones, or islands (sections with "holes" that are disconnected from the surrounding areas) may need to be adapted before a stencil can be created. If your motif has portions with islands, you can add a narrow bridge or two to keep the center piece suspended within the open area. The gaps left by the bridges can be filled with paint after the stencil is removed, resulting in a solid, cohesive print.

1. Transfer your design to the stencil material. If you are using a translucent base to create your stencil, you can place your reference image immediately beneath the material and trace over it using a marker. Printable transparency film, which can be run through most household printers, makes an excellent base material for a stencil because you can print your design directly onto it. Just be sure to get the type of film that corresponds to your printer: inkjet film for inkjet printers and laser film for toner-based printers.

2. Use scissors and a sharp craft knife to carefully cut away the unwanted portions of your stencil.

3. Spray the back side of your finished stencil with a light coat of spray adhesive. This will give your finished print crisp edges and prevent the stencil from shifting as you apply the paint.

Circles are cut out of a piece of transparency film to create a stencil.

Stencils allow you to use the same pattern repeatedly, with different colors if you'd like.

Stencils work equally well with acrylic paint applied with a foam brush, or with spray paint.

4. Paint the exposed areas of your stencil. If you are using spray paint, you may need to mask the outer edges of the stencil with scrap paper to prevent overspray. Depending on the effect that you want to achieve, you can also use a textured sponge, wad of fabric, or other material to apply paint to your stencil.

5. Allow the paint to dry slightly so it is set but not cured. Carefully lift the stencil off of your substrate, using your craft knife along the edges if necessary.

6. Let the paint dry completely, following the manufacturer's recommendations.

7. Touch up any bridges with paint, then allow the stencil to dry again.

Stencils work best on flat or lightly textured surfaces, since rough substrates can lead to gaps along the edges. Stenciled prints can be overlapped and overlaid to make them even more dynamic. Because they're so transportable, versatile, and generally wonderful, stencils are the go-to tool for printing projects in the home, popping up on furniture, walls, decorations, and even floors. They can also be used practically anywhere else— from textiles, such as tees and totes, to paper projects, such as greeting cards and wall art.

STENCILING TOOL KIT

Stencil material, such as
 cardboard or transparency film
Spray adhesive
Spray paint and/or liquid
 acrylic paint

Cyanotype (Sun Printing)

Discovered in the mid-1800s, cyanotype is a type of contact printing that uses ultraviolet rays (such as those present in sunlight) to create a reaction that results in a cyan-and-white image. To make a cyanotype print, paper or fabric is coated in a mixture of ferric ammonium citrate and potassium ferricyanide. An object or photo negative is then placed directly on top of the coated substrate, and the print exposed to UV light. When the print is washed after exposure, the areas that were hidden from the UV rays rinse away, leaving behind eye-catching and detailed silhouettes.

If you'd rather not buy cyanotype sensitizer, cyanotype printing sheets are available at some hobby stores and online (see Resources on page 143). If you choose to buy these pre-treated sheets, you can skip steps 1–3 below.

CREATING A CYANOTYPE

1. Wearing a dust mask and rubber gloves, mix together the cyanotype sensitizer in a dark room, following the instructions provided by the manufacturer. Work quickly, as the sensitizer will only be active for approximately two hours (this may vary slightly depending on the specific sensitizer used).

2. Paint the mixture onto paper or fabric using a paintbrush. This should also be done in a dark (or very dimly lit) room to avoid exposing the print prematurely.

3. Leave the coated substrate in the dark room and allow it to dry thoroughly.

4. Place the coated material onto the piece of wood, then arrange the object(s) to be printed on top of it. You can create detailed images using photo negatives printed onto transparency film or more organic shapes with found objects.

5. Set the glass sheet on top of the elements and the substrate. This will help keep the objects in direct contact with the coated material during the exposure.

6. Place the sandwiched print in direct sunlight. The exposure time will vary depending on the strength of the light. When the visible portions of the material have darkened to a brownish-green color, the exposure is complete.

7. Rinse your print in cold water to remove the excess sensitizer and prevent the white, unexposed areas from turning blue. Agitate the print continuously for approximately five minutes (until the water runs clear). Allowing the material to sit still can create pools that will stain your image.

8. Make a "clothesline" with string and hang your print to dry, using clothespins to attach it to the string.

Although cyanotypes are limited to two colors, they translate gradients and other subtle shifts in tone beautifully. When selecting the base material for your sun print, choose a smooth, light-colored paper or fabric, as they will allow for the greatest contrast. Sun printing can create either photo-realistic prints or soft, natural shapes, depending on the elements that you use as silhouettes.

CYANOTYPE TOOL KIT

Rubber gloves

Dust mask

Cyanotype sensitizer, which has pre-measured amounts of the required chemicals for no-fuss mixing

Paintbrush

Watercolor or etching paper, or light-colored fabric

Piece of wood, flat and cut slightly larger than your print size

Found objects, such as feathers, string, buttons, etc.

Black-and-white image printed onto transparency film

Sheet of glass, cut slightly larger than your print size and free of blemishes

Clothespins

String

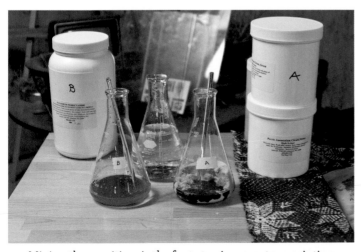

Mixing the sensitizer is the first step in cyanotype printing.

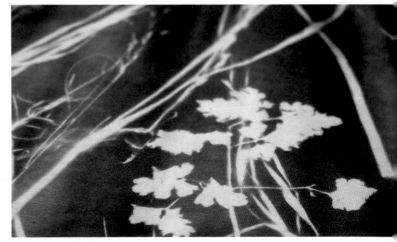

Cyanotype printing leaves unexposed areas white. In this example, botanicals placed on the fabric blocked the sunlight.

TIPS FROM THE PROS

with Nick Sambrato, Jesse Adams, and Brooks Chambers

Whether you're printing commercially or recreationally, it's a good idea to remember that each project begins long before screens are ever involved. At our print shop, Mama's Sauce, projects start with concepts at various stages of development. Sometimes clients come to us with a very specific idea of what they want, and other times they come to us with just a basic sketch. Either way, we approach printing as a creative process with acres of room for artistic vision, and pre-press is where that vision is cast. We look at the artwork and imagine every possible way that it could be translated to print. There are many options available that will faithfully communicate the artist's vision while also yielding unique results.

At the onset of a project, we always ask a few key questions. First: Do various colors overlay? Printing overlays with transparent inks will often result in beautiful secondary colors that the client may not have considered. We have even used transparency to reduce the number of printed colors without changing the design, which saves the client money and can produce a cleaner print. To create transparent ink, all you need to do is add clear screenprinting ink to the colored ink you're working with. The amount of clear ink you use affects how transparent the colored ink becomes, so it takes some experimental mixing to reach the right transparency.

The second question we ask: Is there more than just one design that uses the same color? If so, we will often group designs of the same color on one sheet. This increases efficiency while also faithfully communicating the original vision. And finally: How many final products do we need? If we're printing a large run, we need to start planning for it in the pre-press stage. Perhaps we'll create an emulsion screen with several copies of the same design, and then just cut out each individual card at the end. Or perhaps we'll create a series of screens that take into account variations to a design so we can pull once for two variations.

Patient Troubleshooting

The easiest way to get frustrated beyond belief is to expect every project to run smoothly. A major turning point for us was the day we stopped acting surprised every time something went wrong. Now, we leave room in our plans for surprises, and we recognize that surprises aren't always a bad thing. In fact, they can be signs of progress! For example, if an improvement is made for one step in the process, that adjustment could trigger a surprise mistake in another part of the process that may then need fine-tuning. Screenprinting can be a fussy process, but it always rewards the patient printer.

EXPERT TIP

The tools you use as a printer deserve all the TLC you can give them. From checking with ink manufacturers for storage and usage recommendations to letting your paper breathe overnight in the room where you will be printing, attend to every physical element of your process with the utmost care that you can. Also bear in mind that the success of each run you print will be controlled by the way you cleaned up the run that came before. When you clean your screens after a successful run, are you letting a victory go to your head while your mesh remains plugged with emulsion and ink? It is especially when you are experiencing success that you need to remain humble and methodical in staying the course as you clean, care for, and properly store all of your valuable equipment and materials.

More often than not, a couple of deep breaths are all that stand between the printer and a long-term solution. Most of the time, the only way to get something right is to troubleshoot it on the press. Sometimes that means cleaning the screen and remixing the ink after pulling only two prints, but no matter what happens, patience is key.

Diligent Quality Control

When we go out to eat, we immediately open the menu but not to choose what we'd like to order. Instead, we're poring over the printing—looking at the dot gain on one page, wishing the restaurant had sprung for screenprinting on the cover, and the like. While we would never argue that this behavior is normal or that it makes us fun to be around, we would argue that it is a really good sign. Studying print is essential to printing well. There are things that good printers need to be able to see—pinholes and clogs in the screen, streaking in the ink, and minute mis-registration, to name a few. Once you learn to see these things in prints, you can learn to see them coming on press.

Courageous Experimentation

We know that while screenprinting may not be rocket science, it *is* science. As screenprinters, we wade through practical physics and chemistry all day long. Get to know the chemical and physical constraints of the process firsthand through cautious, directed experimentation. Read everything you can get your hands on, but also remember that you are your own best resource.

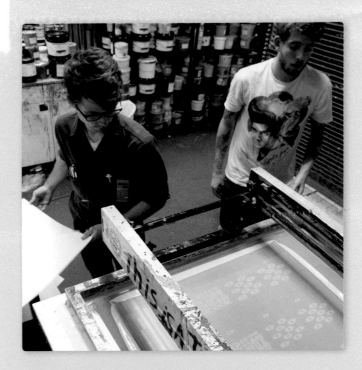

ABOUT THE ARTISTS

Mama's Sauce, a print and design shop in Orlando, Florida, was founded by three Italians—Nick Sambrato, Austin Petito, and Joey Bordenga. They named their business when a happy accident of too much additive turned a normally smooth red ink into a chunky one. The chunky ink sitting in a mixing bowl in the kitchen where they were sceenprinting at the time almost looked like a bowl of spaghetti. Being Italian, they thought the name "Mama's Sauce" was a great parallel.

While they may not mix their inks in a kitchen anymore, they give their spot-color print work the same attention that an Italian Mama gives her Sunday sauce. As they've evolved, their work goes beyond the direct correlation of hand mixing inks in bowls and using fine, wholesome ingredients. It's about taking the time to cook up their projects just right and giving their customers reassurance that Mama's Sauce loves their art as much as they do.

www.mamas-sauce.com

XOXO CARDS

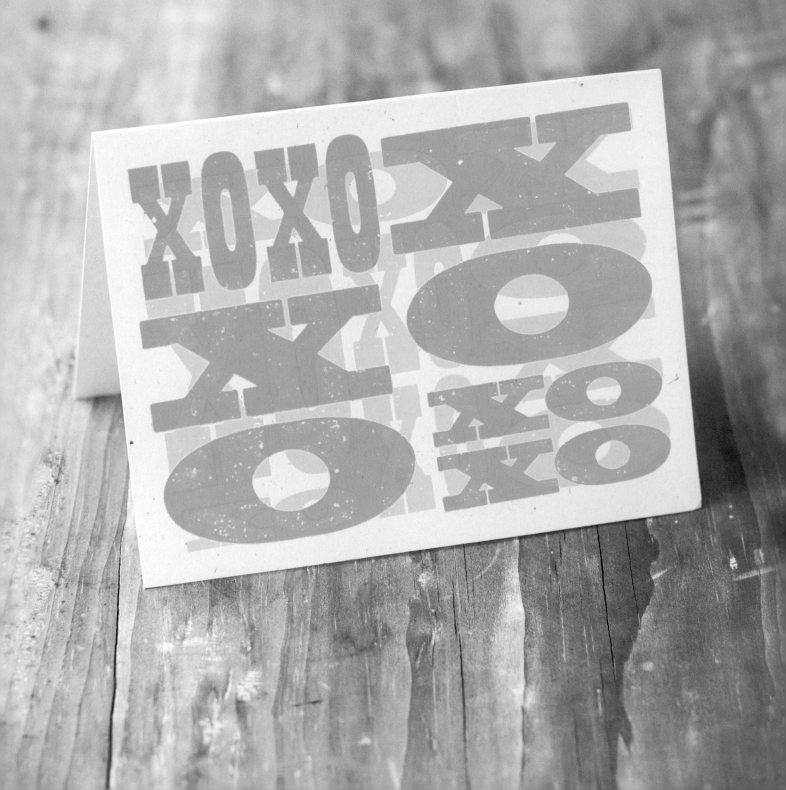

For this design, we mixed clear ink with each color to create a transparent effect, resulting in a third color. The cards at left and on page 42 were designed by one of our clients, 55 Hi's. We provided a very similar template, but the font will be a little different out of respect to their original design. Of course, you can also mix and match other motifs with the instructions below.

What You Do

1. Prepare your screen with emulsion (see Transferring Your Design to the Screen, page 18). Let it dry.

2. Print the XOXO Variation #1 motifs (two layers) onto transparency film using a computer.

3. Burn the motif images (both layers) onto your prepared screen using a UV-exposure unit (see Burning Screens, page 21). *Note*: Because our print runs are large, the screens we burn are large. This allows the design to be burned in repetition on one large screen so that one pull can yield several cards. Double-checking the quality of the burned screen is important for print runs of all sizes (fig. A on the next page).

4. To create the transparent ink, pour one part yellow ink into a container and then add one part clear ink into the same container (fig. B).

What You'll Need

Studio Essentials, page 8

Screenprinting Tool Kit, including one 20 x 24-inch (50.8 x 61-cm) screen, page 16

XOXO Variation #1 motifs (two layers, see the accompanying CD)

Computer and printer

Water-based screenprinting inks: teal, yellow, and clear

White cardstock: 8½ x 5½ inches (21.6 x 14 cm)

Note: This measurement indicates the final dimensions of the card before folding. You can also screenprint on a larger piece of paper and then trim to size before folding.

5. Mix the combination of colored ink and clear ink thoroughly (fig. C). Repeat this process with the teal ink.

6. As you mix your transparent ink, test it on a piece of paper to see how transparent you want the ink to be. Keeping some opaque and transparent inks on the side allows you room to tweak the transparency of your ink later if necessary (fig. D).

7. Register the cardstock to the first image layer on the screen (see Screenprinting Press and Registration, page 26), holding it in place with hinge clamps on your printing table. Place the screen on the right-hand side of the paper so you can fold the paper into a card after the printing is complete.

Note: Whether you are working on a beginner's screenprinting press or using a professional-grade one, the concept and importance of registration is still the same (fig. E, on page 43).

8. Attach low-adhesive screen tape or clear packing tape onto the sections of the screen that you don't want to print. Print the image (see Pulling a Print,

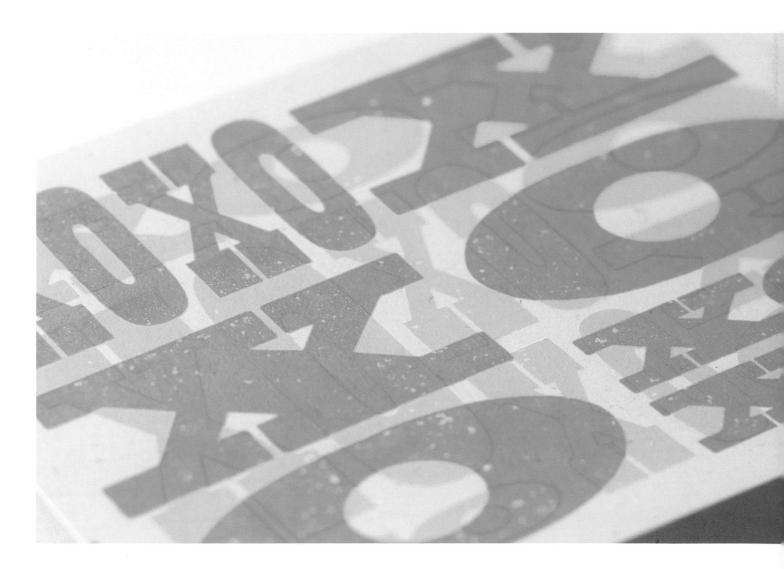

page 25) by flooding the yellow ink mixture over the prepared screen, then firmly pulling the color at an 80-degree angle with a squeegee. Repeat for as many cards as you'd like to make and set them aside to dry. Allow your prints to dry on a flat surface (fig. F).

Note: Because our print runs are large, we use professional-grade drying racks to dry multiple sheets of large-sized paper. If you are a beginner, all you need is a flat surface (such as a kitchen table) where your print can be placed to dry.

9. Rinse the yellow ink mixture from the screen and let the screen dry.

10. Repeat steps 7–8 for the teal layer.

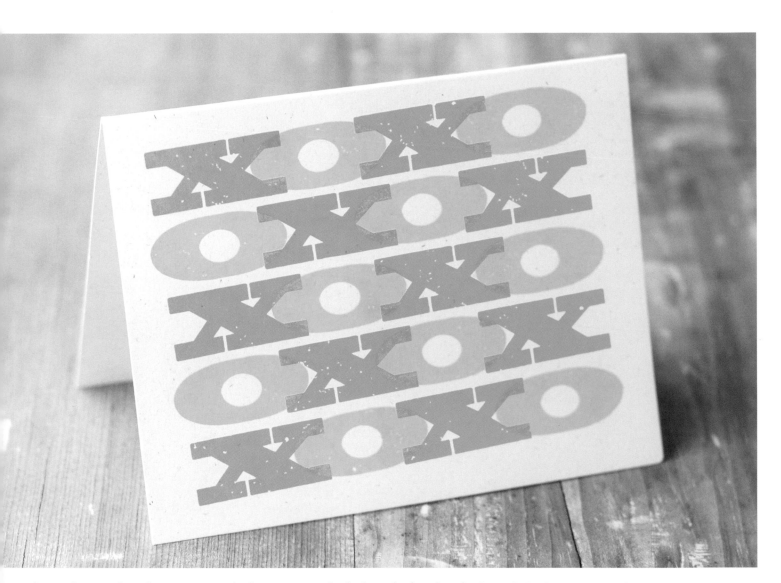

This card was made with a variation to the first XOXO card, which can be found on the CD as "XOXO Variation #2."

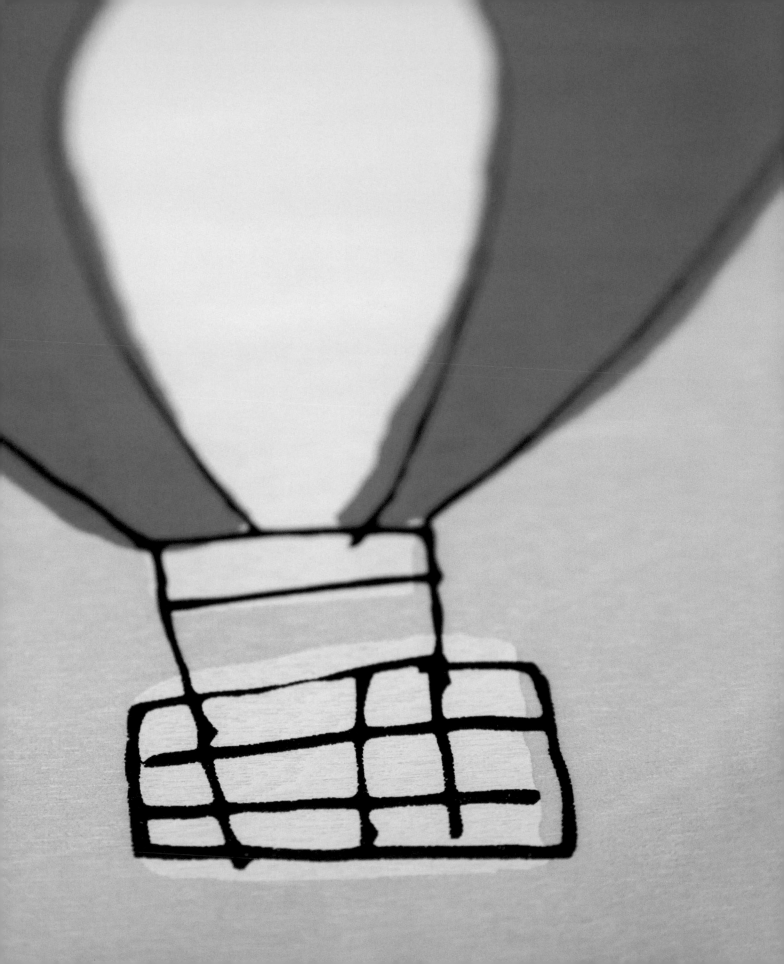

FROM INSPIRATION TO IMAGE
with April Nemeth

My printing process begins with word lists. If I want to make a cute kid's pillow, for example, I will list types of animals, colors, objects, and anything in everyday life that I find cute. It's my way of brainstorming. I am not a person who spends hours in a bookstore referencing other design books, because I feel the ultimate outcome of that is an inauthentic design, and I definitely don't want that. My extensive word lists ensure that my inspiration, and therefore my final prints, are completely original. Inspiration can come from anywhere. It does not have to come from something similar to what you are creating; for me, my original inspiration is often far different than my final outcome. For example, if I see a set of beautiful teacups with roses on them, I don't want to go home and try my hand at creating a set of teacups with roses. But the pattern or colors may spark an idea of my own.

Small and Simple Drawings

I have always been a minimalist in life, and this idea has resonated through my work as well. I find great clarity in simplicity, and I find simple works of art to have a sense of honesty—they are not hiding behind anything. They are what they are. Much of my work can be described as simple, playful, and minimal. In fact, when I am done with an illustration, I make sure it meets these criteria.

From a design perspective, my philosophy is that everything is cuter smaller. My original artwork is usually only about ½ inch (1.3 cm) tall. I redraw and redraw and redraw until I get the art the way I want. I draw on tracing paper or thick paper that has some graininess to it, depending on the look I'm going for. My favorite pen to draw with is the .005 Micron pen. It's the thinnest line I could find that's still dark enough to show up on what becomes a screenprinted image.

I draw on a very small scale so I need the thinnest ink line I can get. I also make sure my lines are far enough apart that certain areas will not plug. Plugging can happen when an "O" is too small, for example. The "O" will fill in and become a solid dot if I'm not careful in leaving enough space.

I go through pens quite fast—not because I run out of ink, but because I press so hard. I don't want to rely on Photoshop to make the design perfect—it never seems as charming. I scan in my line drawings and digitally colorize them using a limited color palette, usually ending up with an illustration that is a combination of two of my favorite versions of the drawing.

Satisfying Printing Results

At this point, I am ready to prepare the files for screenprinting, which entails creating a layer for each color. Fortunately, my simple illustrations are perfect for screenprinting. I usually only use three or four flat colors at the most, and the illustrations are purposely off register. I like to print the different colored layers first, ending with a final layer that consists of a black outline.

After digitally preparing the file for production by scanning my work and then sizing it in Photoshop, I figure out what I'd like to put it on: a onesie, a kid's T-shirt, a block of wood, or an art print. I generally end up wanting to put each design on every product I make, and I usually do! My designs are so small that it's not necessary for me to resize them depending on the substrate, so I'm able to use the same screens for several different products. If I do need to resize an image to better fit a surface, though, I don't hesitate—larger, smaller, whatever it needs to be to look the best.

There are certain things to consider with each printing surface. I have to be much more careful when printing on a garment. There is more room for error and more at stake (mainly because a garment is more expensive than a piece of paper or wood). My favorite surface to print on is wood. It doesn't shift like a garment or paper, and the results are always more satisfying to me.

EXPERT TIP

When your designs are simple, you can make them into dolls by printing them on fabric and then cutting loosely around each image before adding backing fabric and stuffing. Don't worry about making the edges precise—the loose edges complement the simple designs perfectly.

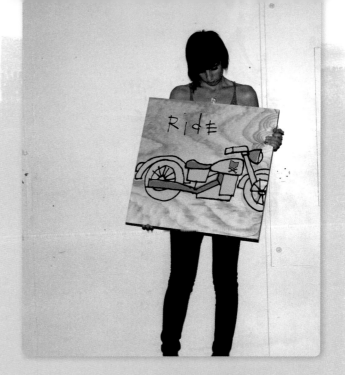

ABOUT THE ARTIST

April Nemeth has been drawing for as long as she can remember. Her parents are strong advocates of the arts, and they always encouraged her to believe she could do anything. Now a professional graphic designer and illustrator, April owns and operates a successful design and illustration shop called Little Korboose when she's not at her full-time job at a greeting-card company. At Little Korboose, she creates a range of products, from screenprinted shirts for tots to modern housewares.

April received her Bachelor of Fine Arts degree from Kent State University, where she developed her Swiss design skills and explored the relationship between form and function. She is inspired by the work of Paul Rand and in love with simple, clean design and mid-century modern architecture and style.

www.littlekorboose.com

BALLOON FLOAT PRINT

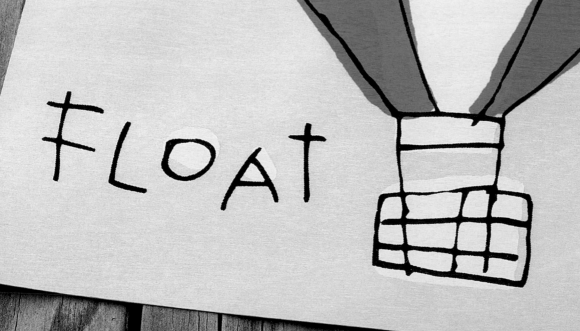

This charming balloon was printed with layers of color and a final black layer for the outline and text. Use this straightforward process with other motifs such as the airplane and bicycle (shown below), if you'd like.

What You Do

1. Prepare one screen with emulsion (see Transferring Your Design to the Screen, page 18). Let it dry.

2. Print the Balloon Float motifs (two layers) onto transparency film using a computer.

3. Burn the motif images (both layers) onto your prepared screen using a UV-exposure unit (see Burning Screens, page 21).

4. Register the wood to the first image layer on the screen (see Screenprinting Press and Registration, page 26), holding it in place with hinge clamps on your printing table.

What You'll Need

Studio Essentials, page 8

Screenprinting Tool Kit, including one 20 x 24-inch (50.8 x 61-cm) screen, page 16

Balloon Float motifs (two layers, see the accompanying CD)

Computer and printer

Water-based screenprinting inks: yellow, orange, and black

Wood panel (see Wood, page 11), 8 inches (20.3 cm) square

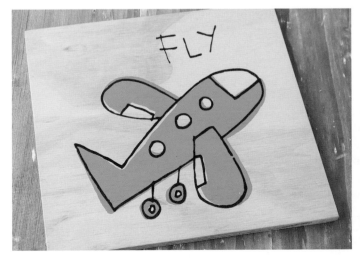

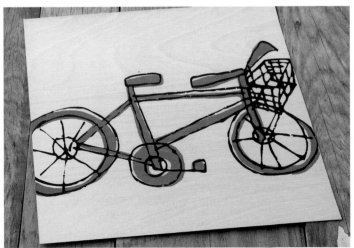

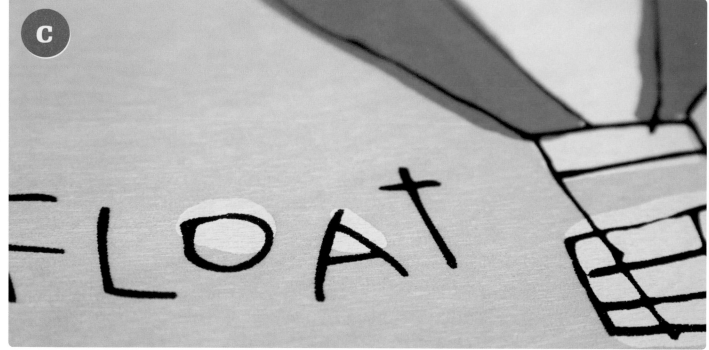

5. Attach low-adhesive screen tape or clear packing tape onto the sections of the screen that you don't want to print. Print the image (see Pulling a Print, page 25) by flooding the yellow screenprinting ink over the prepared screen, and then firmly pulling the color at an 80-degree angle with a squeegee (fig. A). Let it dry.

6. Rinse the yellow ink from the screen and let the screen dry.

7. Repeat steps 4–6 for the orange layer (fig. B) and the black outline/text layer (fig. C).

ALPHABET PRINT

This colorful alphabet would look darling in a nursery or kid's room. The charm of the handwritten letters and the bright colors combine with a clean design and lots of white space for the perfect art print. Each color is printed on a different layer, so play around with different colors and arrangements to make your alphabet unique.

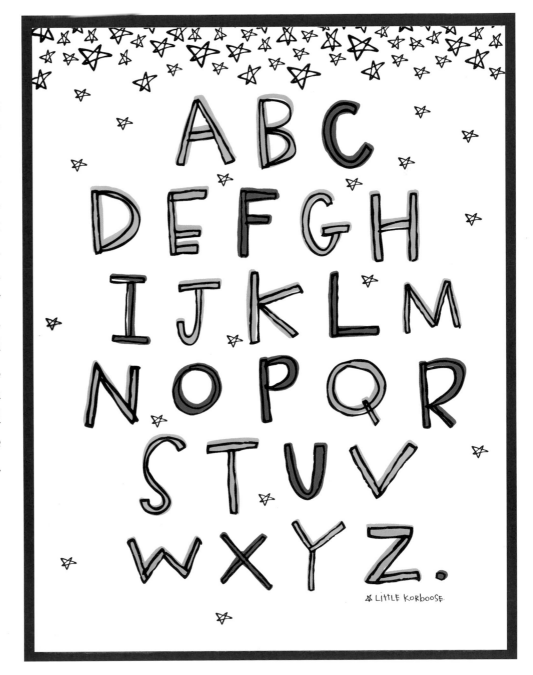

What You'll Need

Studio Essentials, page 8

Screenprinting Tool Kit,
 including two 20 x 24-inch
 (50.8 x 61-cm) screens, page 16

Alphabet motifs (two layers, see
 the accompanying CD)

Computer and printer

Water-based screenprinting inks:
 dark blue, teal, green, and black

White paper, 80 lb., 18 x 24 inches
 (45.7 x 61 cm)

What You Do

1. Prepare two screens with emulsion (see Transferring Your Design to the Screen, page 18). Let them dry.

2. Print the Alphabet motifs (two layers) onto transparency film using a computer and printer. Since the solid Alphabet motif measures larger than an 8½ x 11-inch (21.6 x 27.9-cm) piece of transparency film, print it onto multiple pieces of film transparency by using the tile mode in Photoshop. Connect the pieces of film with transparent tape.

3. Burn the solid image of the alphabet onto your first prepared screen and burn the outline image of the alphabet onto your second prepared screen using a UV-exposure unit (see Burning Screens, page 21).

4. Register the paper to the image on the first screen (see Screenprinting Press and Registration, page 26), holding it in place with hinge clamps on your printing table.

5. Attach low-adhesive screen tape or clear packing tape onto the sections of the screen that you don't want to print. Print the image (see Pulling a Print, page 25) by flooding the green screenprinting ink over the prepared screen, and then firmly pulling the color at an 80-degree angle with a squeegee (fig. A). Let it dry.

6. Rinse the green ink from the screen and let the screen dry.

7. Repeat steps 4–6 for the teal layer and the dark-blue layer (fig. B).

8. Repeat steps 4–6 using the second prepared screen for the black outline layer.

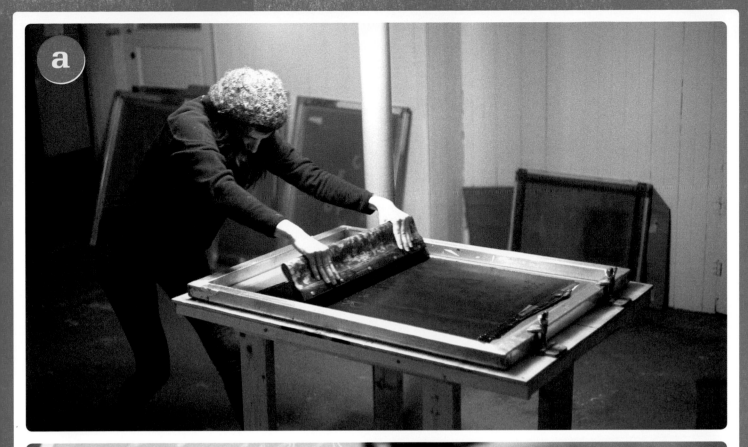

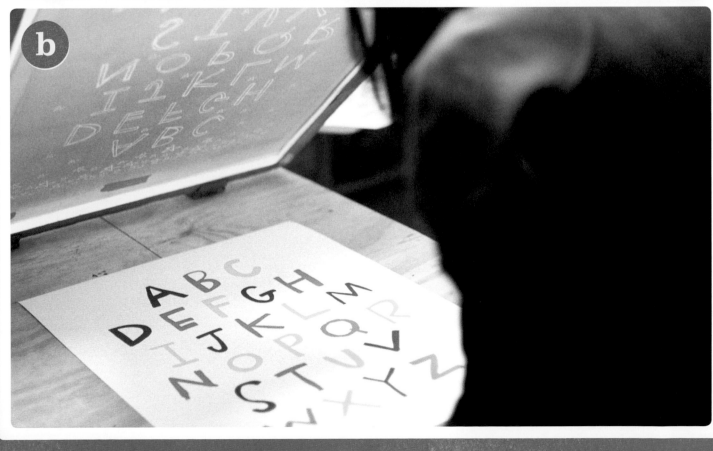

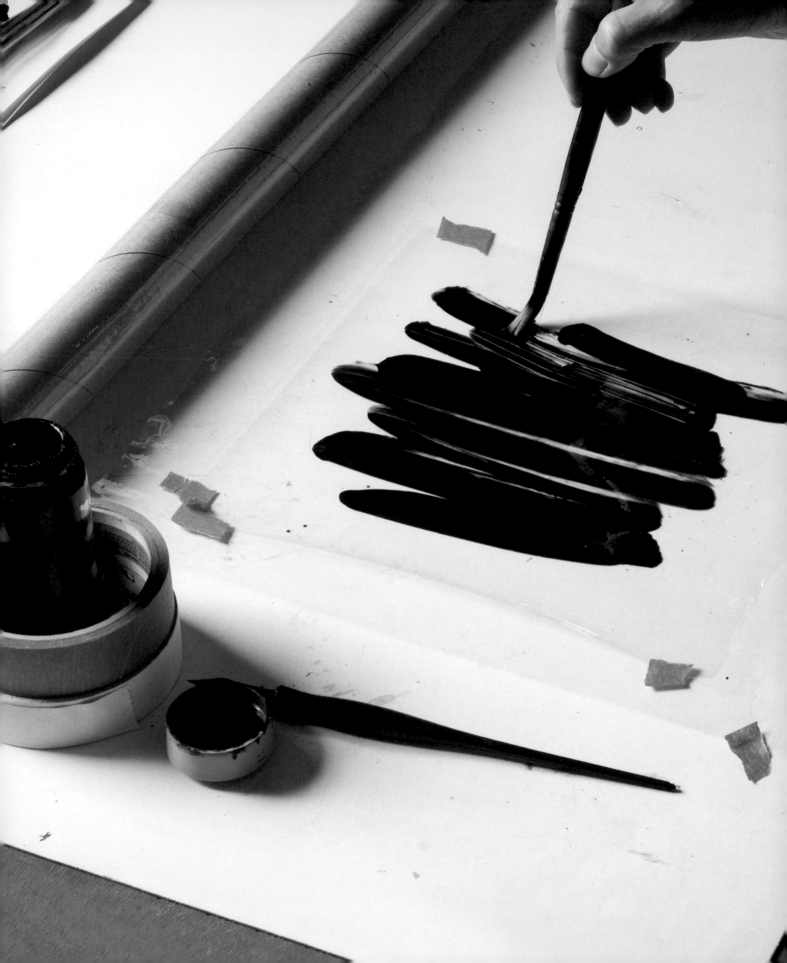

LOOSE, PAINTERLY PRINTING
with Hilary Williams

I approach each piece I print organically and with a painterly mindset. Now, with the introduction of computer programs, screenprints are commonly made from pre-planned stencils and are therefore predictable. While I know that lovely screenprints are produced this way, I prefer to approach my pieces as paintings. By using several loose layers in my prints, I can be more flexible with registration. An added bonus to this method is that if I print something I don't like, I can just create another layer to modify it, or I can simply print over it.

I typically paint with a brush and India ink directly on transparency film to create stencils for my screens.

This results in shapes and lines that aren't completely solid with color. The layers still have crisp edges and a smooth, flat finish (as with any screened image), but it is clear that a paintbrush has done the work. I also play around with dripping the India ink to look like paint drips on a canvas, which always throws the viewer off in a fun way. I sometimes create additional texture with swift motions of the brush or by dabbing off some of the ink in certain places with a cloth or paper towel. Creating stencils in this manner ensures that I'm never able to tell exactly how a piece is going to turn out until the very end.

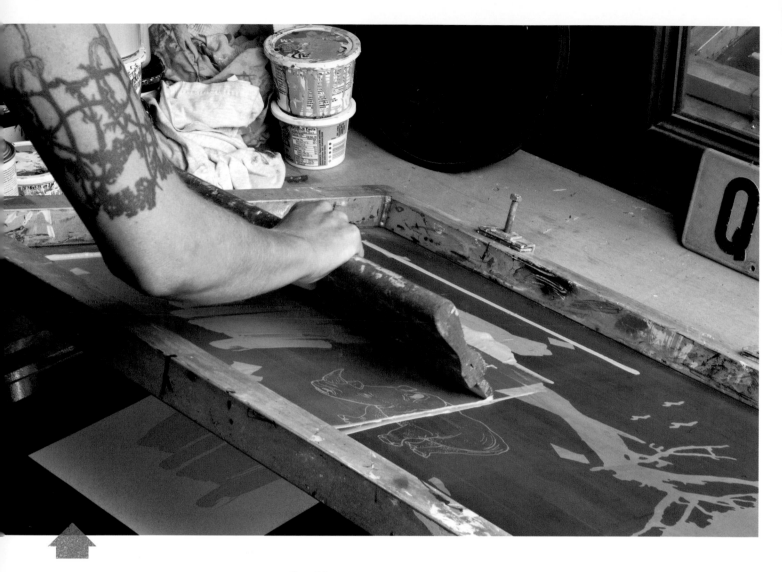

EXPERT TIP

Every screenprinter should know how to execute a tightly registered print before experimenting with looser layers. As the saying goes, "Know the rules before you break them!" Tight registrations can always be a complement to other loose layers in your final prints. See page 26 for more on registration.

Finding Art in Loose Layers

Not only do I work with stencils that are more painterly and fun in nature, but I also make it a point to not stress about tight, precise registration. For some printers, it is important that everything lines up exactly right, but I don't mind if one layer is a slight millimeter off in registration. It makes for enjoyable surprises while printing—something peeking out of a corner, or two layers combining to create something unexpected—even when using a medium that can otherwise be so planned out.

Usually when creating a print, the artist plans the layers and colors ahead of time, but I also enjoy designing a print from start to finish with more of an open mind. I'll just start printing and see where the layers take me. I'll print a couple of layers and then ask, "What should I do next?" I'll

then design the next layer and see how it all comes together along the way. I'll notice how the colors from previous layers are interacting with each other, and then decide which colors to use, sometimes even printing multiple versions in different colors to pick my favorite.

By approaching the screenprint this way, I allow my prints to form slowly and organically as pieces of art. It is more like starting and finishing a painting, where it is not done until the artist is pleased with the result. This approach and mind-set in printing could be just what you are looking for.

ABOUT THE ARTIST

Hilary Williams has been enthralled with screenprinting since she was first introduced to it as a student at the California College of the Arts. The graphic nature and layered bold colors of a single print fascinate her. She creates limited-edition prints, and she also incorporates screenprinting into her painting and fabric works. Through layering, collage, and juxtaposition, she strives to make art that expresses the absurdity, poignancy, and joy of the world.

Continually inspired by today's natural and urban environments, she works through her feelings about the coexistence of nature, humanity, and urban landscapes in her pieces. Through her art—which is always infused with healthy doses of humor, irony, and melancholy—she aims to create a surreal vision of reality that incorporates the past, present, and future, all to cause reflections on where we are today.

www.hilaryatthecircus.com

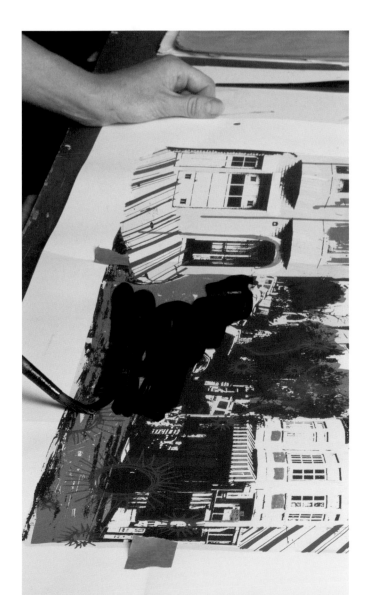

COW
GREETING
CARD

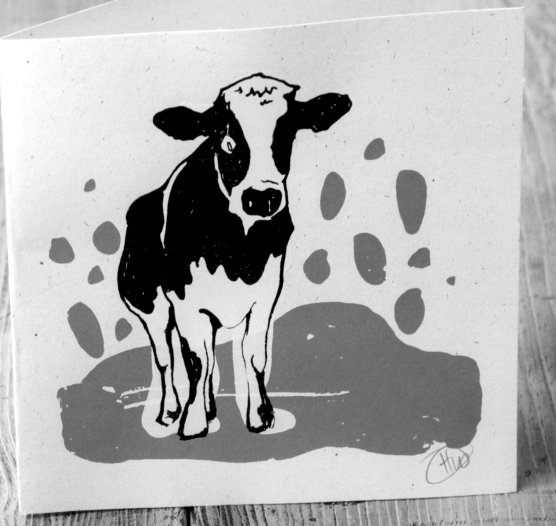

This greeting card will charm any recipient and gives you the opportunity to play with a paintbrush and ink directly on transparency film. Remember not to worry about making your lines and shapes perfect; the imperfections only add surprise and personality to the finished product.

What You Do

1. Prepare your screen with emulsion (see Transferring Your Design to the Screen, page 18). Let it dry.

2. Print the Cow Greetings motifs (three layers) onto transparency film using a computer, or find a photo reference of a cow from a book or online and draw your own images onto transparency film as follows (see figures A–C on page 60 to get an idea of what each layer looks like):

 ➡ On one sheet of film, draw the cow's outline and spots with a dip pen and India ink. Use the motif/photo as a guide for the drawing, or lay the film on top of the reference to trace it. Set the drawing aside to dry.

 ➡ On the second sheet, paint the filled-in shape of the cow with a small paintbrush and India ink, referring to the drawn cow to ensure they are the same size. Set the painting aside to dry.

 ➡ On the third sheet, paint the background. The background should be the loosest, most organic image, where you allow the paintbrush to create a painterly, one-of-a-kind context for the cow. Set it aside to dry.

3. Burn the motif images (all layers) onto your prepared screen using a UV-exposure unit (see Burning Screens, page 21).

4. Register the paper to the first image layer on the screen (see Screenprinting Press and Registration, page 26), holding it in place with hinge clamps on your printing table. Place the screen on the right-hand side of the paper so you can fold the paper into a card after the printing is complete.

What You'll Need

Studio Essentials, page 8

Screenprinting Tool Kit, including one 20 x 24-inch (50.8 x 61-cm) screen, page 16

Cow Greetings motifs (three layers, see the accompanying CD) or photo reference of a cow (optional)

India ink (optional)

Dip pen (optional)

Paintbrush (optional)

Paper, 80 lb., 6 x 6¼ inches (15.2 x 15.9 cm)

 Note: This measurement indicates the final dimensions of the card before folding. You can also screenprint on a larger piece of paper and then trim to size before folding.

Water-based screenprinting inks: blue, yellow, and black

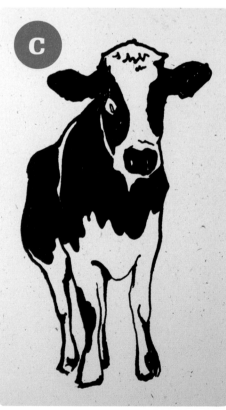

5. Attach low-adhesive screen tape or clear packing tape onto the sections of the screen that you don't want to print. Print the image (see Pulling a Print, page 25) by flooding the blue screenprinting ink over the background image, then firmly pulling the color at a 60-degree angle with a squeegee (fig. A). Repeat for as many cards as you want to make and set them aside to dry.

6. Rinse the blue ink from the screen and let the screen dry.

7. Repeat steps 4–6 for the yellow layer (fig. B) and the black outlined layer (fig. C).

8. Trim the cardstock, if necessary, and fold it in half to make a card.

MISS RHINO PRINT

This four-color layered print features a friendly pink rhino. The juxtaposition of the more technical feel of the rhino outline next to the freeform paint splatters and unique colors creates a humorous effect. Though created in a similar manner as the Cow Greeting Card (see page 58), this print features a fourth layer, which you'll create by flecking paint with a toothbrush.

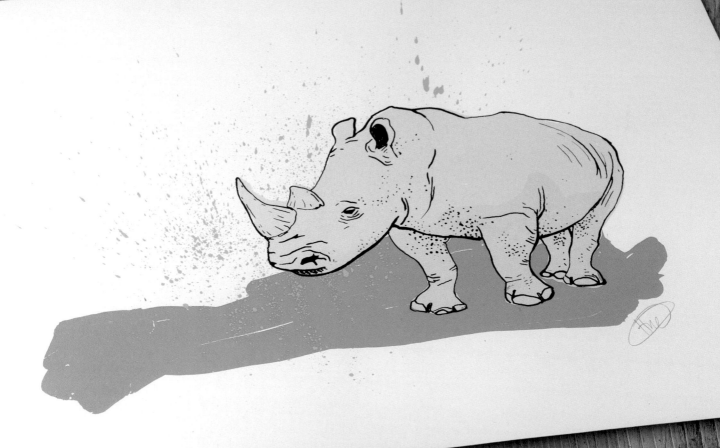

What You'll Need

Studio Essentials, page 8

Screenprinting Tool Kit, including one
 20 x 24-inch (50.8 x 61-cm) screen
 and one 10 x 14-inch (25.4 x 35.6-cm)
 screen, page 16

Miss Rhino motifs (four layers, see
 the accompanying CD) or photo
 reference of a rhino (optional)

India ink (optional)

Dip pen (optional)

Paintbrush (optional)

Toothbrush (optional)

Paper, 80 lb., 16 x 12½ inches
 (40.6 x 31.8 cm)

Water-based screenprinting inks:
 green, blue, pink, and black

What You Do

1. Prepare two emulsion screens (see Transferring Your Design to the Screen, page 18). Let them dry.

2. Print the Miss Rhino motifs (four layers) onto transparency film using a computer, or find a photo reference of a rhino from a book or online and draw your own images onto transparency film as follows (see figures A–D at right to get an idea of what each layer should look like):

 ➥ On one sheet of film, draw a rhino with a fountain pen and India ink. Use the motif/photo reference as a guide in drawing, or lay the film on top of the reference to trace it. Set the drawing aside to dry.

 ➥ On another sheet, paint the filled-in shape of the rhino with a small paintbrush and India ink, using the drawn rhino as a guide to ensure they are the same size. Set the painting aside to dry.

 ➥ On a third sheet, fleck India ink with a tooth-brush to create a speckled pattern. Set the sheet aside to dry.

 ➥ On a fourth sheet, paint broad strokes in a loose, organic fashion. Set the sheet aside to dry.

3. Burn the two background motif images onto your first prepared screen and burn the two rhino motif images onto your second prepared screen using a UV-exposure unit (see Burning Screens, page 21).

4. Register the paper to the first screen (see Screenprinting Press and Registration, page 26), and hold it in place with hinge clamps on your printing table.

5. Attach low-adhesive screen tape or clear packing tape onto the sections of the screen that you don't want to print. Print the image (see Pulling a Print, page 25) by flooding the green screenprinting ink over the image, then firmly pulling the color at a 60-degree angle with a squeegee (fig. A). Let the print dry.

6. Rinse the green ink from the screen and let the screen dry.

7. Repeat steps 4–6 for the blue speckled layer (fig. B). Switch screens and repeat for the pink shape layer (fig. C) and the black outline layer (fig. D).

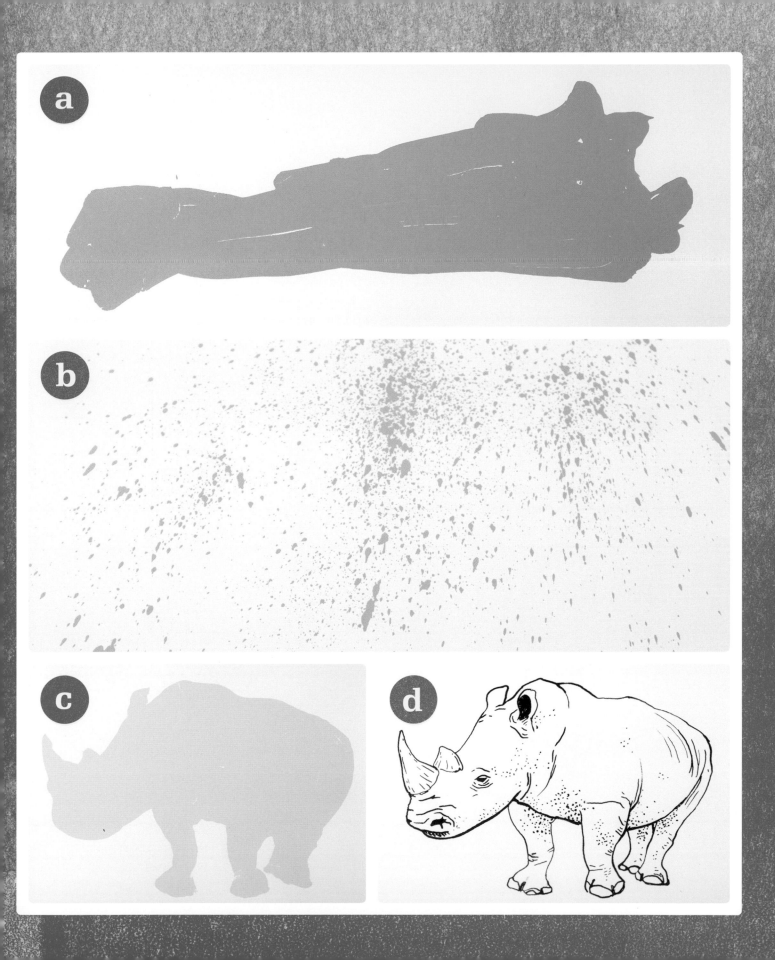

USING BRIGHT INKS
with Yuriko Iga

My process involves traditional screenprinting methods. However, what makes my work unique is that I like to use very bright inks. When you work with bright inks, what you want in the end are vibrant products with high contrast and energy. What you don't want is a muddy mixture of colors that feels muted or weighed down! There are a few tricks I've learned over the years as a screenprinter that help ensure bright inks really stand out in my final pieces.

The first thing I learned is to select colors that contrast with each other. For example, rather than creating a print with red, orange, and yellow, I would use a combination like purple, orange, and green. Another trick is to make sure that you pull in only one direction, rather than back and forth and side to side. Pulling in one direction leads to a crisper, brighter image, as does pulling the color the least amount of times possible. Pulling a color more times than is necessary will blur the image—between one and three passes is all that I will ever do. Lastly, bright inks have the best contrast on white fabric, but they also stand out on plain black fabric and light-colored wood as well.

You don't need fancy tables, hinges, or registration devices to produce good work. Don't get me wrong—I'm sure that the tools and materials developed for screenprinting available on the market are extremely useful for many people, especially those who are making large volumes in terms of products that they sell. However, I enjoy using my natural abilities, such as eyeballing registration and using my hands to control the screen, rather than relying on the high-tech tools of the trade. Once I have my screens burned and masked and I've laid down my dollop of color, it's all about the art of the squeegee and achieving the right angular pressure. The key is to keep that 70-degree angle. This can make the difference between a smeared and a clear image. And with bright inks, a clear image is particularly important. Because bright, neon inks can be hard to see, any smearing is detrimental.

Incorporating Fabric

You can use your artistic license to experiment with surface design on fabrics before incorporating screen designs. I work with paper, ceramics, and just about any other surface that I can get my hands on, but the volatile and unpredictable nature of fabric really appeals to me. Almost no two prints on fabric will look exactly the same.

Sometimes bright inks are best paired with clean white fabric, but I also love layering a crisp screenprint atop a messy, organic background. To this end, I often paint fabric with dye and a foam brush to give it more of a handmade look.

Trial-and-error is key when incorporating fabrics into your screenprinting work. Different brands of dyes will affect various fabrics in new ways, and then screenprinting inks will appear differently depending on the dyes used. I typically dye my fabric with Rit dye; it works best with any washable fabric, such as 100-percent cotton and linen. I'm constantly experimenting with new inks, but Speedball has a fluorescent line that is particularly fun to work with. Even though bright inks may not show up quite as well on dyed fabric, sometimes that isn't what's important—sometimes it's just as interesting to print bright inks on a dyed or a dark background for a more subtle effect. Occasionally

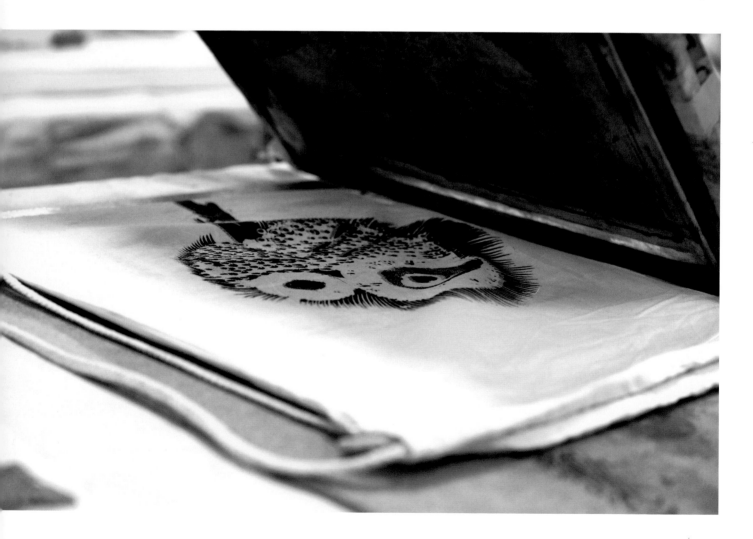

I'll print on fabric that I made a mistake on when dyeing—it's a fun challenge to see if I can fix the dyed mistake with an interesting screenprint!

I typically dye a few small pieces of fabric for test runs, using the same inks that I plan on using for my final prints. That way, I can make adjustments if necessary before creating the final prints. Adjustments may include using a different color of dye, or perhaps not loading up the brush as much before painting on the dye. Test runs are also a chance to adjust the inks, particularly if I'm mixing colors.

EXPERT TIP

Don't feel like you need to be able to draw in order to screenprint. Look for interesting images online or elsewhere that you can scan in and manipulate on your computer.

ABOUT THE ARTIST

Art has never been a question of "if" or "when" for Yuriko Iga—it's just always been there. A painter and a sketcher from an early age, she's experimented with everything from ceramics to costume design. As a student in college, Yuriko discovered that university art was too structured for her colorful vision, which led her to explore the art of dance. Eventually Yuriko earned a degree in sculpture at the Alberta College of Art and Design. She also became interested in creating installation-based sculpture art, where she could create the whole space instead of just one object. This evolved into hosting events where music, art, and color would combine to set the scene for social gatherings.

With each event, one thing remained consistent—the need to communicate the details to a wide audience. Enter screenprinting—the art form that allowed Yuriko to market, announce, and communicate her events with unique handmade artistry. Through it all, screenprinting has remained her main love. As a way to communicate, inspire a broad audience, and play with color, screenprinting stimulates and challenges Yuriko every day.

www.blim.ca

RAINBOW OWL
WOOD BLOCK

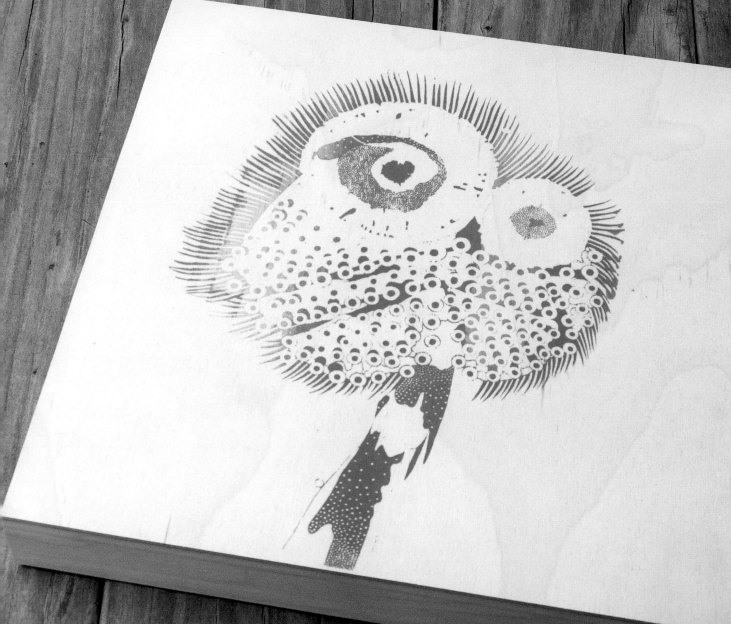

Light-colored wood is an ideal surface for bright inks. The grain creates a subtle background, which helps keep the inks in check. Printing on wood is no more difficult than printing on paper, but it's still a good idea to pull a couple of test prints on paper first. It's better to make a mistake *before* you print your final piece!

What You Do

1. Prepare one screen with emulsion (see Transferring Your Design to the Screen, page 18). Let it dry.

2. Print the Owl motif onto transparency film using a computer.

3. Burn the image onto your prepared screen using a UV-exposure unit (see Burning Screens, page 21).

4. Register the wood block to the owl image on the screen (see Screenprinting Press and Registration, page 26) using packing tape as a reference point. Lay the block on the printing table.

5. Print the image (see Pulling a Print, page 25):
➡ Place dollops of pink, yellow, and red screenprinting inks onto the screen, leaving a small space between each dollop so they don't overlap too much when you pull the colors.
➡ To achieve the rainbow look, pull all the colors at once using a consistent and firm 70-degree angle with the squeegee, making sure you pull in a straight line. Let the ink dry.

What You'll Need

Studio Essentials, page 8
Screenprinting tool kit, including one 20 x 24-inch (50.8 x 61-cm) screen, page 16
Owl motif (see the accompanying CD)
Computer and printer
Water-based screenprinting inks: pink, yellow, and red
Block of wood (see Wood, page 11), 12 inches (30.5 cm) square

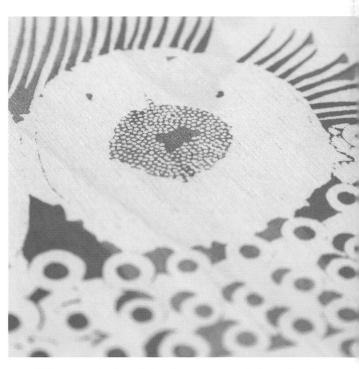

Although only three ink colors were used, the red and yellow inks blend to appear orange, making the print look like it was pulled with four ink colors.

OFFSET OWL TOTE

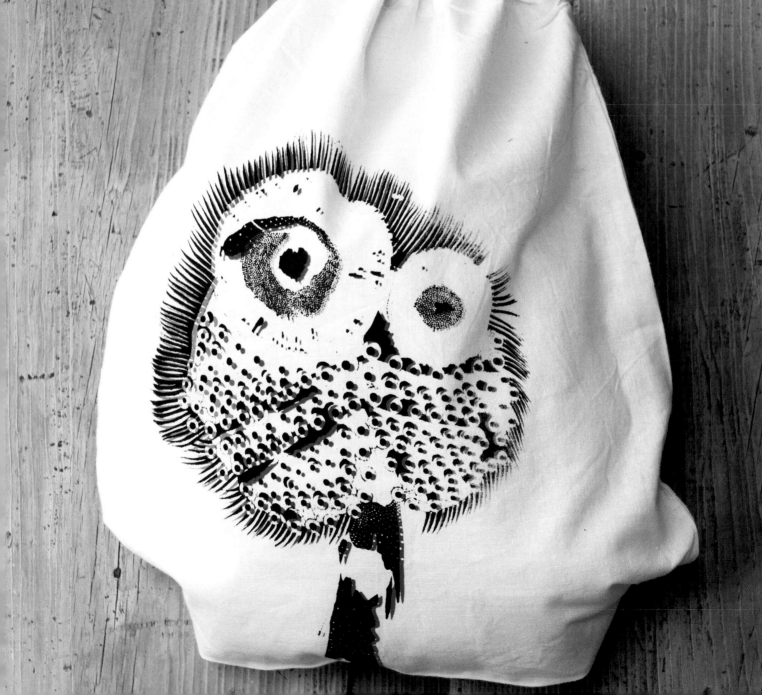

Neon inks on white fabric can seem too bright. In this project, you'll use the same screen to print neon colors and then a second layer in black. A slight offset means the neon inks will be partially obscured by the black ink. They will come through, but not take over, the resulting design.

What You Do

1. Prepare your screen with emulsion (see Transferring Your Design to the Screen, page 18). Let it dry.

2. Print the Owl motif onto transparency film using a computer and printer.

3. Burn the image onto your prepared screen using a UV-exposure unit (see Burning Screens, page 21).

4. Spray non-permanent adhesive to the cardboard and insert it into the tote bag so the adhesive touches the inside front of the tote bag. Pat the tote bag smooth, making sure to remove any wrinkles. Register the tote bag with the cardboard insert to the image on the screen (see Screenprinting Press and Registration, page 26) using packing tape as a reference point. Lay the tote flat on the printing table.

What You'll Need

Studio Essentials, page 8

Screenprinting tool kit, including one 20 x 24-inch (50.8 x 61-cm) screen, page 16

Owl motif (see the accompanying CD)

Computer and printer

Light-colored fabric tote bag with drawstrings, roughly 13 x 15 inches (33 x 38.1 cm)

Cardboard, 13 x 14 inches (33 x 38.1 cm)

Non-permanent spray adhesive

Water-based screenprinting inks: pink, green, purple, and black

USING DARKER FABRICS

Bright inks can also work on darker fabrics, especially grays. The contrast is not as dramatic but the subdued effect can be beautiful and elegant.

5. Print the image (see Pulling a Print, page 25):

➡ Place one dollop each of pink, green, and purple screenprinting ink onto the screen, leaving a small space between each dollop so they don't overlap too much when you pull the colors (fig. A).

➡ To achieve the rainbow look, pull all the colors at once using a consistent and firm 70-degree angle with the squeegee, making sure you pull in a straight line. Let this layer dry (fig. B). Rinse out your screen and let it dry.

➡ Offset your screen by ³⁄₁₆ inch (5 mm) from the first print on the tote bag. Flood the image with black, and pull it through the screen. To ensure that the underlying neon colors show through, don't pull the black through more than twice (fig. C). *Note*: When you want your screenprinted layers to be offset, be careful not to offset your screen much more than ³⁄₁₆ inch (5 mm). You're looking for just a hint of the rainbow layer.

6. Remove the cardboard insert and use an iron to cure the fabric tote (see Curing a Fabric Print, page 25).

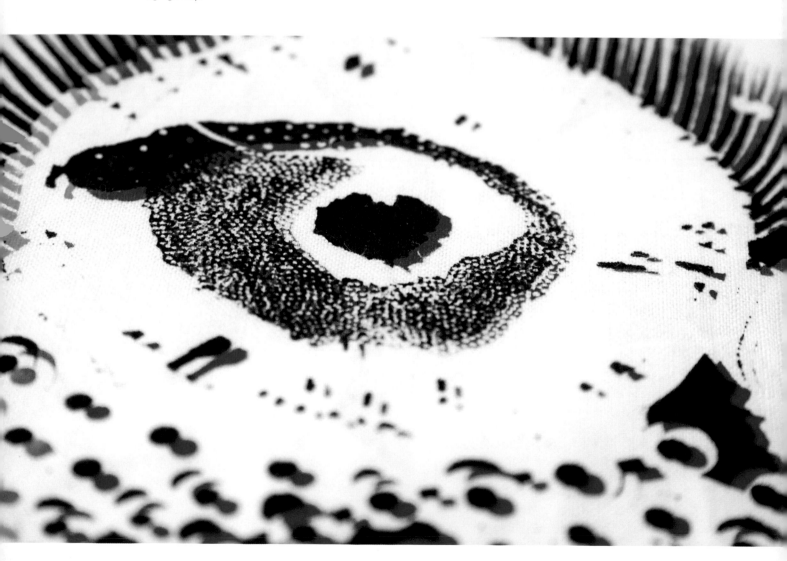

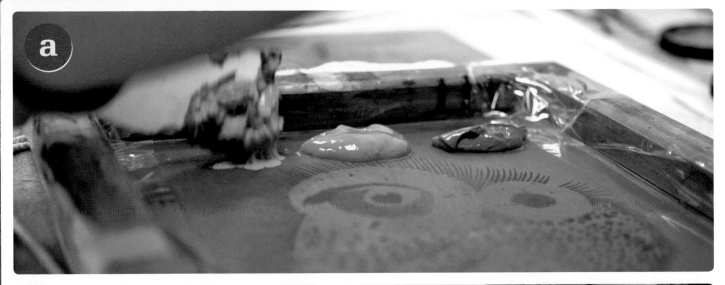

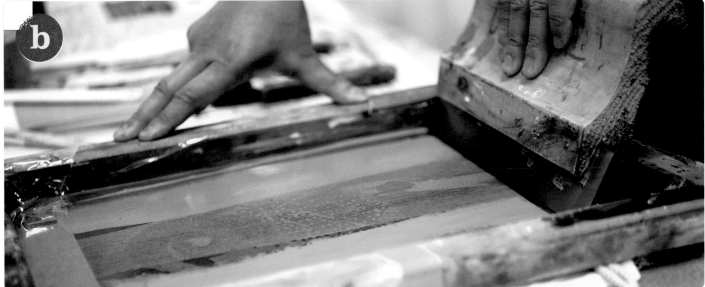

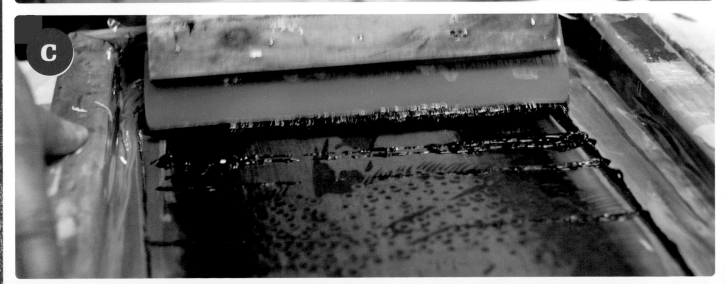

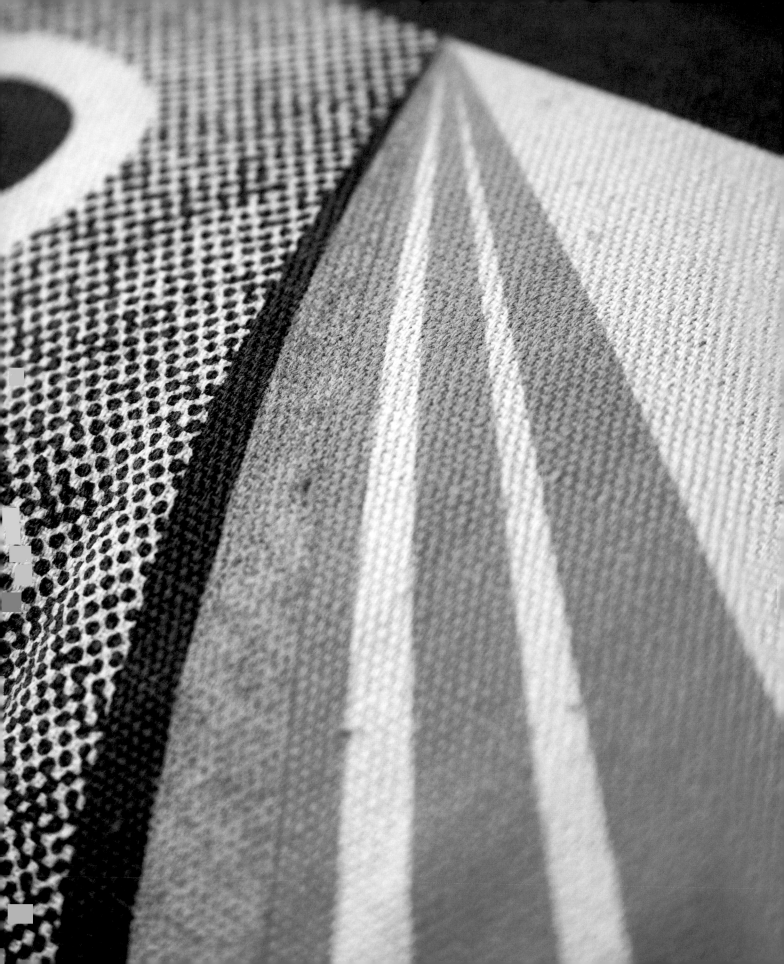

OVERPRINTING
with Anneke Kleine-Brüggeney

Every time I start a project, I think in terms of layers. This is because a separate screen is needed for each color, and I've learned to make use of this in my designs. I usually start the design process with a rough sketch on paper and then transfer it to the computer to further develop it in a graphics program. On the computer, I can try out transparency effects and get an impression about the balance and proportion of the colors. I work with layers in two main ways. First, I use rasterized areas in which the spaces between the dots reveal the underlying color. I do this by blowing up black-and-white photographs from newspapers instead of generating them on the computer because I prefer the slightly rough look that contrasts with the clean covered areas in a print.

My second approach to layering colors lies in the technique. Screenprinting inks are never 100-percent opaque, so you always see the underlying colors through the last printed layer. Instead of starting out with the lightest color and working up to the darkest one—a more standard printing procedure—I turn this order around. Simple and effective, this method creates new colors in addition to the limited palette of inks I actually use.

Printing in layers requires planning ahead. When I finish the preliminary design and planning stages, I prepare the film and expose the screen before making my final color decisions. I usually take the time to try out different combinations by making a test print or two first. This gives me the chance to adjust the transparency of my inks, if necessary, by adding transparent extender base.

Precise Placement before Play

Once my inks are set, I take my time in preparing the printing table and screens. Because I work with multi-layered prints, I always pay particularly close attention to registration. I want to print so the layers fit together precisely. In order to get that right, I always have some pieces of perfectly straight cardboard prepared to serve as my registration marks. As soon as the screen is in place, prepared, and fixed on the table with hinge clamps, I put my first piece into printing position. Before putting any ink on the screen, I tape at least three registration marks to the table, close to the corners of my future print, to make sure I know exactly where to place each print so they can all be pulled in the same position.

Making sure the registration is precise before pulling any color ensures all the following runs are much easier. I find the correct printing position only once per layer, mark it, and then just put the following prints in the same place. This may all sound a little complicated at first, but your first multicolor print will definitely reward you for all the preparation.

I also make sure to experiment and try out all sorts of things, so don't get too discouraged by the "right way" to do this. Get your inks ready, roll up your sleeves, and have fun playing!

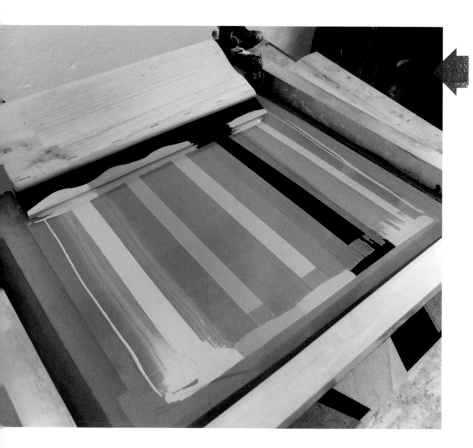

EXPERT TIP

If you'd like to test how different colors interact with each other, tape off a couple of stripes on a screen, and then secure the screen and a piece of fabric (or paper) to your printing table with hinge clamps. Scoop a little dollop of all of your ink options on the stripes, one color per stripe. Pull them with the squeegee all in one stroke and use a hair dryer to dry the inks quickly. Turn the fabric or paper 90 degrees and print a second time on top of the first print. The result will show all possible combinations of the inks used and allow you to check if the overlapping parts show the intended shade.

Altering with Rotation

My prints are often square shaped, which allows me some flexibility in printing. With a square design, I'm free to rotate layers 90 or 180 degrees if I want to alter the final print. This works best with the kinds of abstract patterns that I use for my postcards. Even with slight alterations, because of the rotated layers I'm able to create completely new designs. The faces used for the pillowcases can't be rotated like the abstract patterns, but they can be altered by varying the combinations of layers and colors, and the order in which the layers are printed.

As I'm rotating layers, it's fascinating to watch how the different placements affect the interactions among the colors. Occasionally I'll find that I need to mix new inks to highlight a different part of the design, but most of the time I'll use the same inks and just enjoy the variations. It's an opportunity to overlap shapes, create new looks, and use the limitation in color to create a two-dimensional work of art that has almost three-dimensional qualities.

ABOUT THE ARTIST

When Anneke Kleine-Brüggeney graduated from university, it didn't take her long to realize that she wasn't at all prepared for a job in the design industry. After all, she had maneuvered through college by tinkering and collaging rather than setting type and arranging layouts. She quickly decided she needed a career that would allow her to create with her hands instead of sitting in front of a computer all day doing work she couldn't identify with. She wanted to get her hands dirty and realize her own projects and ideas.

So, with very little money and a lot to learn, she moved to Cologne with her boyfriend, took a couple of bread-and-butter jobs, and found a place where she could live and work at the same time. After much trial-and-error, she built her own exposure unit and printing table to complete her fully working screenprinting studio.

www.bombinastudios.de

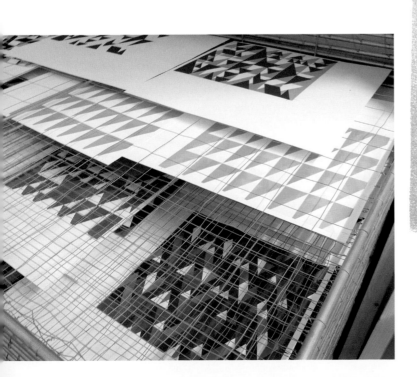

BEASTS OF ALL KINDS PILLOW-CASES

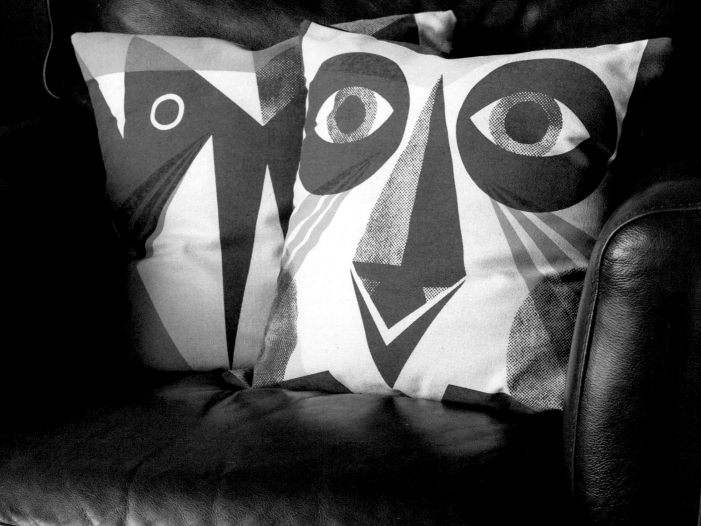

These fun, quirky pillowcases make a statement on any couch. The layers in this project are designed to combine with all of the others, so have fun playing with different combinations and colors, as well as printing layers in different orders. The instructions here are for a pillowcase that features blue, green, and pink inks.

What You Do

1. Prepare two emulsion screens (see Transferring Your Design to the Screen, page 18). Let them dry (fig. A).

What You'll Need

Studio Essentials, page 8

Screenprinting Tool Kit, including one 20 x 24-inch (50.8 x 61-cm) screen, and one 10 x 14-inch (25.4 x 35.6-cm) screen, page 16

Beast motifs (three layers, see the accompanying CD)

Computer and printer

Water-based textile screenprinting inks: blue, green, and pink

Transparent extender base for textiles

Cotton fabric scraps

Cotton fabric: one 17⅓-inch (44-cm) square for each pillow

Cardboard: one 17⅓-inch (44-cm) square for each pillow

Non-permanent spray adhesive

Cardboard scraps

Backing fabric: two 11¾ x 17⅓-inch (30 x 44-cm) pieces for each pillow

Sewing machine

Thread

Pins

Pillow insert, 16-inch (40.6-cm) square

2. Print the Beast motifs (three layers) onto transparency film using a computer and printer. Since these motifs measure larger than an 8½ x 11-inch (21.6 x 27.9-cm) piece of transparency film, print the motif onto multiple pieces of film transparency by using the tile mode in Photoshop. Connect the pieces of film with transparent tape (fig. B).

3. Burn the images onto your prepared screens using a UV-exposure unit (see Burning Screens, page 21). Burn the Beast face onto the larger screen, and the geometric motif layers onto the smaller screen.

4. Prepare each ink color by adding a bit of transparency extender base to each one and mixing thoroughly. Before continuing with the project, conduct a transparency test to see if you like your mixed inks and to see how they look when layered together (see Transparency Test, opposite page).

5. Use non-permanent spray adhesive to place the fabric onto a sheet of cardboard. Register the fabric-covered cardboard to the Beast face image on the first screen (see Screenprinting Press and Registration, page 26), holding it in place with hinge clamps on your printing table. The motif on the screen should sit squarely in the middle of the fabric.

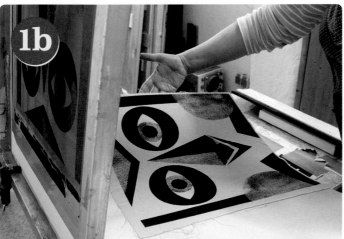

TRANSPARENCY TEST

To determine if you've reached the right level of transparency, do a test print of the bottom layer:

1. Register a scrap piece of fabric to the table, add the first ink, pull the color, and let it dry (figs. 1a and 1b).
2. Tape off stripes on a screen, holding the screen in place with hinge clamps, and add a little bit of each color onto each of the stripes. Pull the colors once and let them dry. Turn the scrap of fabric 90 degrees and print the stripes a second time on top of the first print (fig. 2).
3. Cut out pieces of the fabric to look at some of the combinations in isolation. Then you can easily choose your favorite combinations (fig. 3).

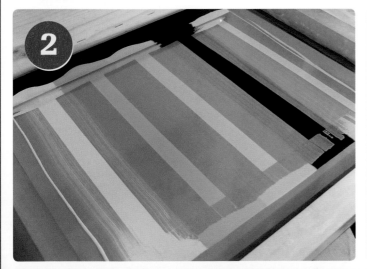

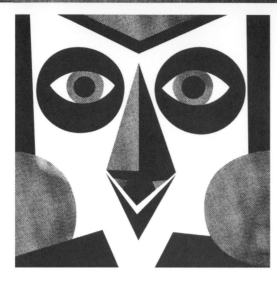

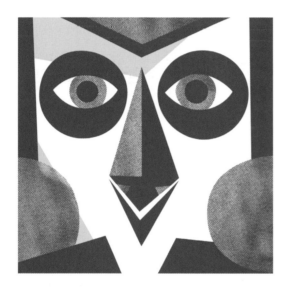

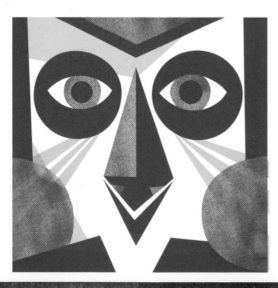

6. Print the image (see Pulling a Print, page 25) by flooding the blue ink mixture over the screen, then firmly pulling at an 80-degree angle with a squeegee. Let this layer dry (fig. C).

7. Switch screens, and attach low-adhesive tape or clear packing tape onto the sections of the screen that you don't want to print. Print the first geometric layer by flooding the pink ink mixture over the screen, then firmly pulling the color at an 80-degree angle with a squeegee. Let this layer dry (fig. D).

8. Rinse the pink ink mixture from the screen and let the screen dry.

9. Repeat steps 7–8 for the second geometric layer using the green ink mixture (fig. E).

10. When the inks are completely dry, remove the fabric from the cardboard and cut along the borders of the motif, allowing a ⅜-inch (.95-cm) seam allowance. Press the fabric for 2 to 3 minutes to set the inks (see Curing a Fabric Print, page 25). Press the backing fabrics as well.

11. Starting with one backing piece, press under the right edge by ⅜ inch (.95 cm), then press under another 1¼ inch (3.2 cm). Stitch a straight line along the edge of the folded piece. Do the same for the other backing piece, but press and stitch the left edge this time.

12. Lay the printed piece of fabric on a flat surface, right side up, then lay the backing pieces down on top with the two folded edges overlapping in the middle. Pin around the entire edge of the pillow. The overlapping fabric in the middle forms the opening where you will insert the pillow. Stitch all four sides with a ½-inch (1.3 cm) seam allowance, pivoting at the corners. Trim the fabric diagonally at the corners, then turn the pillow cover right side out and insert a pillow.

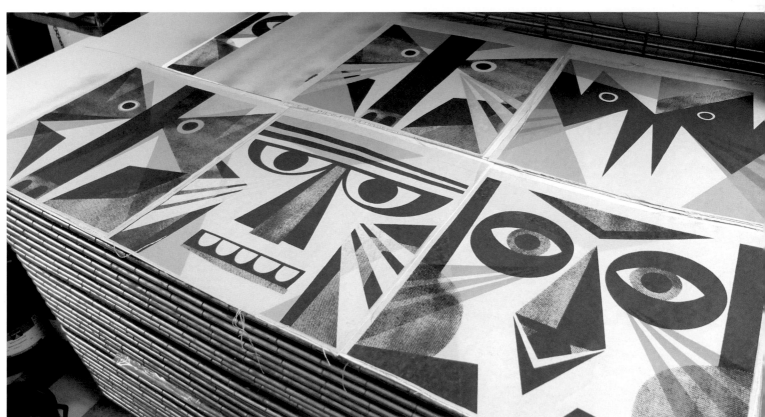

GEOMETRIC POSTCARDS

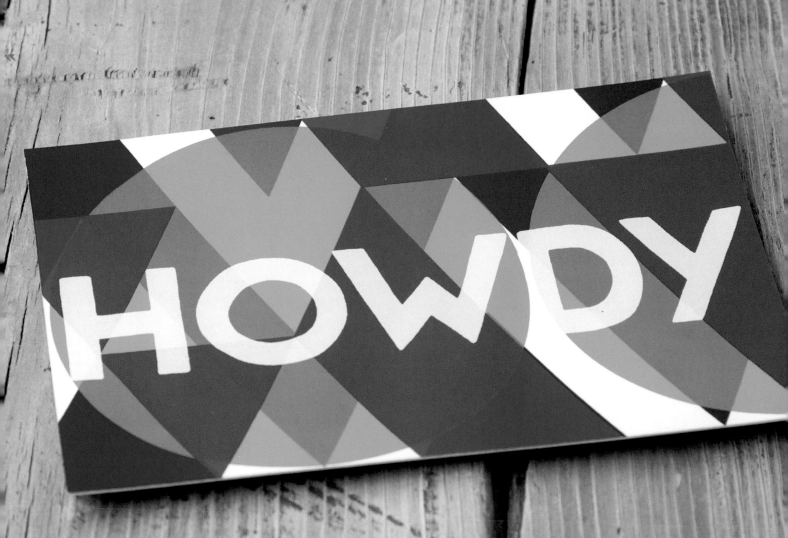

Combine bright geometric patterns with fun sayings for a unique postcard. All layers in this project are designed to combine with each other, so play with combinations of colors, layers, and variations. You can use the motifs provided on the accompanying CD to make two-, three-, or four-color designs!

What You Do

1. Prepare your screen with emulsion (see Transferring Your Design to the Screen, page 18). Let it dry.

What You'll Need

Studio Essentials, page 8

Screenprinting Tool Kit, including one 20 x 24-inch (50.8 x 61-cm) screen for each layer, page 16

Geometric Postcard motifs (two to four layers, see the accompanying CD)

Computer and printer

Water-based screenprinting inks: assorted colors

White cardstock: 8½ x 11 inches (21.6 x 27.9 cm)

Note: **This cardstock will be trimmed to create two 5 x 7-inch (12.7 x 17.8-cm) postcards (fig. A).**

2. Print the Geometric Postcard motifs (two to four layers depending on your preference) onto transparency film using a computer and printer. Because the motifs measure larger than 8½ x 11 inches (21.6 x 27.9 cm), you'll need to use the tile print mode in a photo-editing program like Photoshop to print the design on several sheets. Piece the sheets together using clear packing tape.

3. Burn the images onto your prepared screens using a UV-exposure unit (see Burning Screens, page 21) (fig. B).

4. Register the cardstock to the first geometric image layer on the screen (see Screenprinting Press and Registration, page 26), holding it in place with hinge clamps on your printing table.

5. Attach low-adhesive screen tape or clear packing tape onto the sections of the screen that you don't want to print. Print the image (see Pulling a Print, page 25) by flooding your first ink color onto the screen. Firmly pull the color at an 80-degree angle with a squeegee. Repeat for as many cards as you want to make and set them aside to dry.

6. Rinse the ink from the screen and let the screen dry.

7. Repeat steps 4–6 for each additional geometric shape layer (fig. C) and the final text layer (fig. D). Cut the cardstock to create two 5 x 7-inch (12.7 x 17.8-cm) postcards.

 DOUBLE-SIDED DUTIES

If you find your cardstock is moving around during a print run, use several small pieces of double-sided tape to adhere the paper to the table. If the tape is so sticky that it will damage the paper when removed, decrease the stickiness by carefully rubbing it first with a piece of cloth or with your hands.

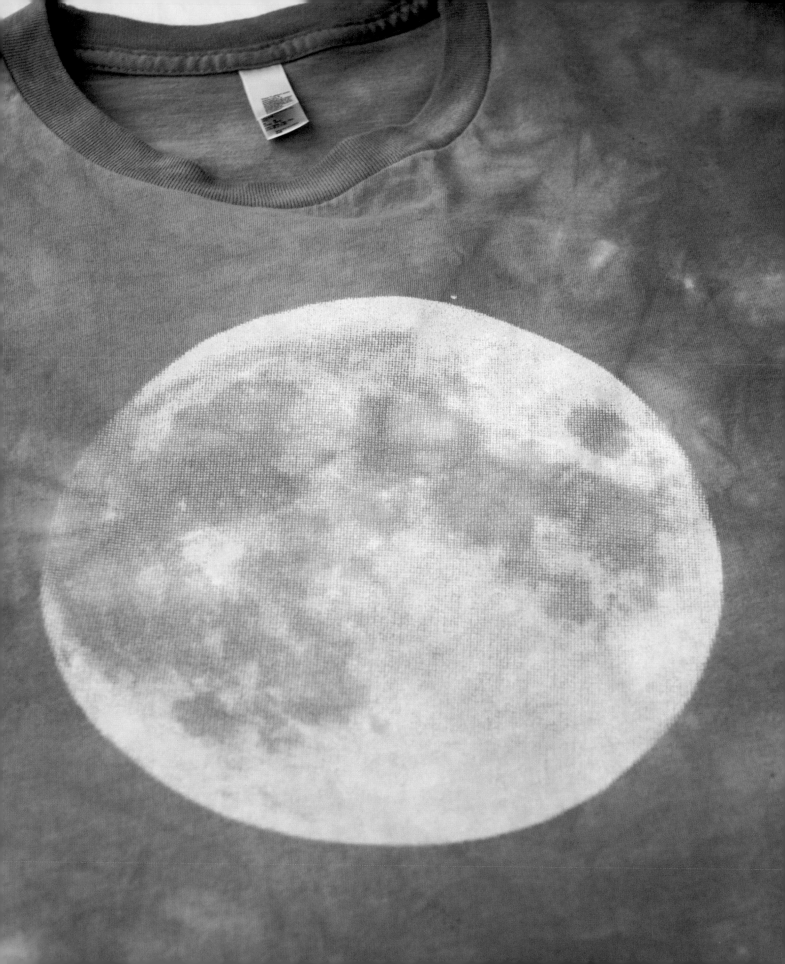

USING INTERESTING SUBSTRATES

with Amy Fierro

My traditionally screenprinted products often start with dyed textiles. I find that dyeing the textiles first adds another layer of interest and color that I really enjoy, plus it widens my horizons when I'm not happy with the textile color as is. I dye my fabric with Rit dye bought at the drugstore. Using my giant Le Creuset pot and following the instructions on the bottle, I can create really fun surfaces to print on. I prefer the uneven look of hand-dyeing because it has a watercolor quality that appeals to me, and it looks especially cool with a bold, graphic screenprint.

I generally dye a bunch of shirts with a specific project in mind. I like to pick the right color of dye that will go with whatever image I'm printing. Planning ahead allows me to print multiples of one project, which I can then sell in my shop. When it comes to choosing fabric—whether I'm printing a shirt or a tote—I always print on natural, non-woven fabrics, such as cotton, bamboo, or hemp. Since I print with water-based screenprinting inks, I don't use any man-made fabrics, such as nylon, because the ink would not adhere to it. I always aim for somewhat even coverage when dyeing, so each piece is consistent, yet still one of a kind.

Water-based screenprinting inks can appear somewhat transparent, especially when printed on dyed fabrics, so I'm mindful of color combinations. Dark inks obviously show up better on light fabrics, whereas lighter inks on darker fabric can be a little bit trickier. Ensuring I have enough ink on my screen before pulling it, and then pulling the color two or three times, helps those light inks show up better.

I play around with a lot of different color options on the computer prior to printing. When working in Photoshop or Illustrator, it's easy to try out a number of different palettes before it's time to gather and mix ink. Once the ink is mixed, I print test strips to make sure it prints the way it looks on screen. I find that ink color can appear different depending on the mesh count of the screen. Inks can also print differently than expected depending on the dye specifics of the fabric or color of paper I'm printing on, so I always take time to make sure everything looks right.

Going Further

When I screenprint on paper, I lean toward bright, interesting paper colors. Because the screenprinting ink will show up differently on colored paper than on white paper, I always make sure to do a few test runs before my full print run. If I want to be sure the ink will show up as close to its original color as possible, I make sure the ink is very opaque. The more transparent the ink, the more you'll be able to see the colored paper through the ink.

Lately, I've been experimenting with Soft Scrub, a household cleaner. It has the same viscosity as ink, but it contains bleach. When I print with it, it bleaches

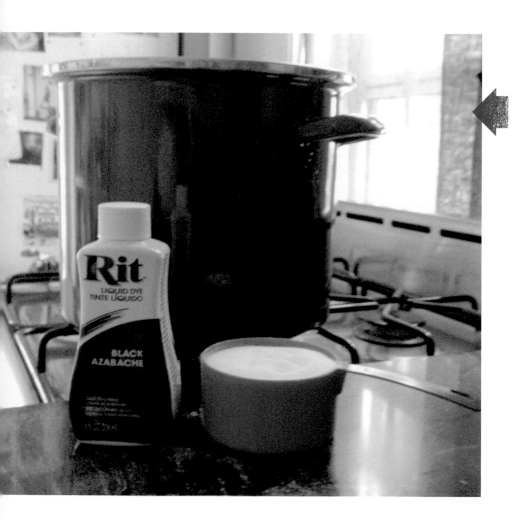

EXPERT TIP

Not only do I print test screenprints to ensure my ink is the color I'm aiming for, I also experiment heavily with Rit dye. I've used it enough now to know that the black color tends to turn out more violet than black for me, but it took me a while to understand this result. Be sure to play around with the dye on your specific fabric before you're ready to screenprint on it. Understanding how the dye works with your fabric will lay a good foundation for a printing surface.

ABOUT THE ARTIST

Amy Fierro's first attempts at screenprinting came as a teenager. She was very interested in pop art, especially the work of Andy Warhol and Robert Rauschenberg, both of whom incorporated screenprinting into their art-making methods. So she bought a little Speedball kit and started playing around. She's been painting, drawing, and making art for as long as she can remember.

Amy holds degrees from the Fashion Institute of Technology and the Savannah College of Art and Design. She currently runs Bright Beige, a design and screenprinting studio, in Brooklyn, New York. She also teaches a screenprinting class at an art workspace in Brooklyn, where she shows students basic printing techniques as well as how to set up their own printing space at home. She enjoys showing people how accessible and rewarding printing is by demystifying the process, encouraging them to experiment, and giving them the tips she's learned the hard way over the years.

www.brightbeige.com

the fabric instead of printing another color on it. I'm never really sure how it will turn out, especially on dyed fabric, but I've really enjoyed the results so far. The only drawback to working with it is that it eats up the emulsion on my screen, so I have to work quickly if I want more than a dozen pulls with one screen.

You can also play up the fact that each item is a tiny bit different when you're screenprinting—perhaps the ink didn't push through the mesh on one print, or maybe two colors overlapped by accident. I enjoy the inconsistencies and not hiding "my hand" from what I'm printing. I always have happy accidents. Part of the fun is tinkering along the way—throwing in a new color if inspiration hits, dyeing the fabric in a different way, or working with a new "ink." If you're willing to experiment and try some different ideas, you can get really amazing results.

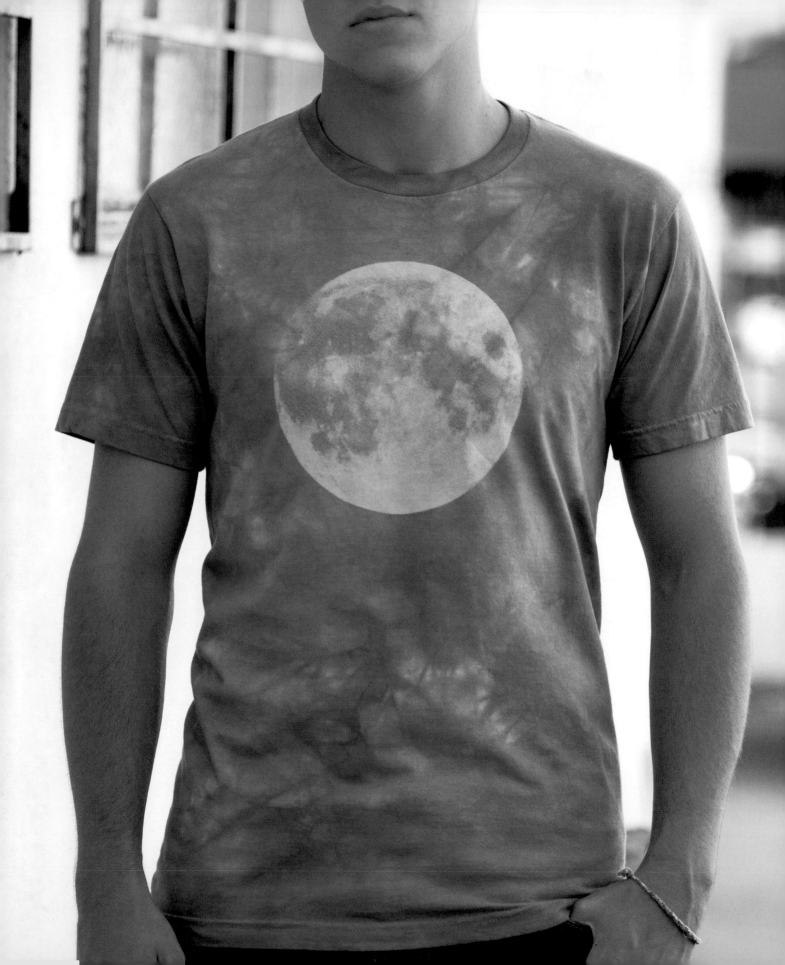

MOON T-SHIRT

This is a single-color screenprint on a dyed T-shirt. The high-resolution photograph of the moon was altered in Photoshop to make it screenprint-worthy, meaning the levels were adjusted so the shadowed areas appeared darker and the light areas appeared lighter. On a T-shirt that's been dyed a dark color, working with contrast and brightness levels ensures the image will show up on a dark shirt.

What You Do

1. Prepare your screen with emulsion (see Transferring Your Design to the Screen, page 18). Let it dry.

2. Print the Moon motif onto transparency film using a computer and printer.

3. Burn the image onto your prepared screen using a UV-exposure unit (see Burning Screens, page 21).

What You'll Need

Studio Essentials, page 8

Screenprinting Tool Kit, page 16

 Note: Because the high-resolution moon photo has such fine details, consider using a screen with a higher mesh count, such as 230.

Moon motif (see the accompanying CD)

Computer and printer

Natural fiber T-shirt

Non-permanent spray adhesive

Cardboard: as wide and long as the area being printed on the T-shirt

Black fabric dye

Pot for dyeing

Water-based screenprinting ink: white

4. Dye the T-shirt with black fabric dye following the instructions on the bottle (fig. A).

5. Rinse the dyed shirt in cold water and let it dry.

6. Spray non-permanent spray adhesive to the cardboard and insert it into the T-shirt so that the adhesive touches the inside front of the shirt. Pat smooth the section of the T-shirt to be printed onto the cardboard, making sure to remove any wrinkles. Register the T-shirt with the cardboard insert to the image on the screen (see Screenprinting Press and Registration, page 26) using packing tape as a reference point. Lay the T-shirt flat on the printing table.

7. Print the image (see Pulling a Print, page 25) by flooding the white screenprinting ink over the screen, then firmly pulling the color at an 80-degree angle with a squeegee (fig. B). You may have to pull the color a few times for adequate coverage. Remove the cardboard and let it dry.

8. Heat-set the print with a hot iron or a cycle in the clothes dryer. This will prevent the ink from fading too quickly after being washed.

DISCO DOGS CARD

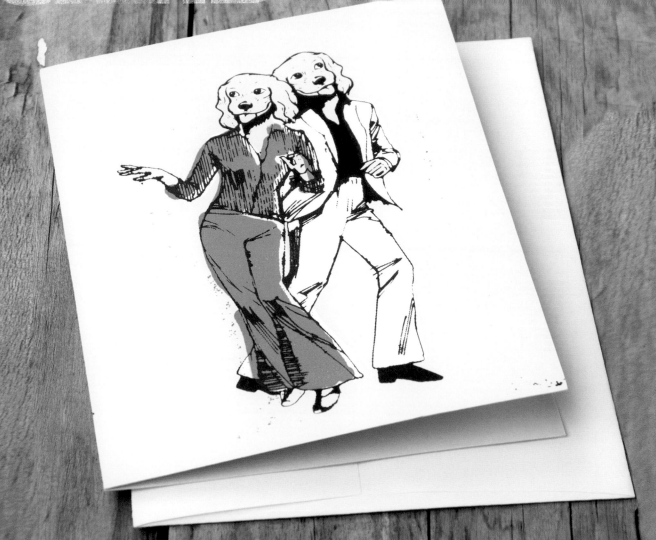

This three-color screenprint was made from a collage of found images. Because the finished piece is so small, Amy was able to fit all three layers on the same screen. If you'd like to fit them all on the same screen as well, simply use packing tape to cover the colors you aren't printing.

What You'll Need

Studio Essentials, page 8

Screenprinting Tool Kit,
including one 20 x 24-inch
(50.8 x 61-cm) screen, page 16

Disco Dogs motifs (three layers,
see the accompanying CD)

Computer and printer

Water-based screenprinting inks:
white, black, and mauve

Yellow cardstock, 9 x 6 inches
(22.9 x 15.2 cm)

Note: This measurement
indicates the final dimensions
of the card before folding. You
can also screenprint on a larger
piece of paper and then trim to
size before folding.

What You Do

1. Prepare your screen with emulsion (see Transferring Your Design to the Screen, page 18). Let it dry.

2. Print the Disco Dogs motifs (three layers) onto transparency film using a computer and printer.

3. Burn the motif images (all layers) onto your prepared screen using a UV-exposure unit (see Burning Screens, page 21).

4. Register the cardstock to the first image layer on the screen (see Screenprinting Press and Registration, page 26), holding it in place with hinge clamps on your printing table (fig. A). Place the screen on the right-hand side of the paper so you can fold the paper into a card after the printing is complete.

5. Attach low-adhesive screen tape or clear packing tape onto the sections of the screen that you don't want to print (fig. B).

6. Print the image (see Pulling a Print, page 25) by flooding the white screenprinting ink over the image, then firmly pulling the color at an 80-degree angle with a squeegee. Repeat for as many cards as you want to make and set them aside to dry (fig. C).

7. Rinse the white ink from the screen and let the screen dry.

8. Repeat steps 4–7 for the mauve layer (fig. D) and the black outline layer (fig. E).

9. Trim the cardstock if necessary, and fold it in half to make a card (fig. F).

 # REGISTERING ART, PAPER, AND SCREEN

When creating a multicolor print, it is very important that you pay close attention to registering your art, paper, and screen—particularly when you're using the same screen for all the layers. If you know the exact position of the paper and the art for every layer, all of the colors will end up where they should.

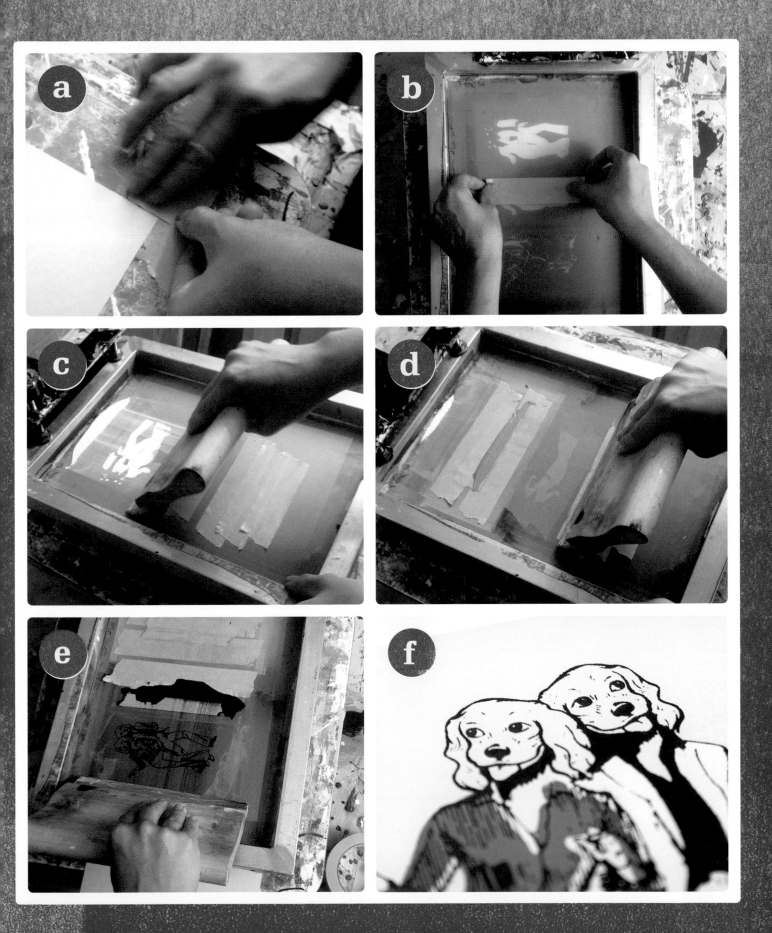

PRINTING TEXT
with Patrick Edgeley

Since I worked in graphic design for more than twenty years I have a fondness for type and often include some sort of text in my prints. Including text is not that different from including art elements—the basic screenprinting process remains the same. However, you are limited by size when you work with text. If you use very small type, the screens clog up easily and the ink can smudge together. Making sure you have enough space between the lines of the text ensures a successful print.

I love retro fonts and Americana—mid-century design and type work are particularly appealing to me. I look at vintage packaging, illustrated children's books, newspapers, and shop signs for text inspiration. When

I pulled the floorboards up in our new home to replace them, I found a number of household items that were at least 50 years old—matchboxes, newspapers, even tooth-cleaning powder in a beautiful printed tin—and the fonts on those packages are still inspiring my work today.

Being on the lookout for inspiring fonts keeps my work fresh and exciting. I have a collection of letters from shop fronts, including some art-deco numbers that were being replaced in a 1930s block of flats we lived in. I came home from a holiday to France with a huge box of old French letters that are fantastic. Text really is an art form itself, and I don't think you can beat the combination of beautiful text and fun art elements.

Drawings Turned into Designs

Drawing is the first step in all of my screenprints. I never use images or shapes directly from the computer; even if I find an image online that I like, I always draw a version of it to give the final print a handmade quality. Most of the time, I just start from scratch. I create some of my text with a computerized font in mind, but I always hand-draw it in my own style before scanning it in, just like I do with my images. I also enjoy creating fonts from scratch. Not having to rely on following the specifics of a certain font means I can draw the text to better fit a specific illustration.

I draw each element separately in black pen on paper; this allows me to scan each one in and then combine and move the elements around in Photoshop. Since most of my prints involve several different elements, I find it works best to do the arranging and designing of the actual print on the computer. Like most graphic designers, I tend to obsess over details. I like to register all my layers perfectly, and I can spend hours rearranging the different elements in a design until I am completely happy and my partner has long gone to bed shaking her head in disbelief. This early design stage of drawing and computer work can be a long process—and I have as many prints as I have unused ideas that didn't make it to print—but a successful print makes it all worth it.

EXPERT TIP

My biggest piece of advice for using text in your screenprints is to always check your spelling early on! You don't want to get to the end of the process and realize that something is spelled wrong.

Color Arrangement

With screenprinting, it's important to think about the order in which you'll print the colors—particularly when you're working with several layers. I often have six or more colors in one piece, which means determining the order is a must before I begin actually printing. In general, it's best to print the lighter and more transparent colors first, followed by the more opaque, darker inks. Colors with a high content of white pigment are also very opaque, so I always print them toward the end, as well.

Of course you can alter the order in which the colors need to be printed by adding transparency or opacity ink to them. For example, a light, pale color becomes more opaque with opacity ink, so you can print it on one of the upper-most layers and it will still show up. Because I scan all the elements into Photoshop and arrange the composition there, I'm able to work with color options on the computer as part of the early design process. When I'm happy with how the image looks in Photoshop, I simply separate the various elements into colors—every element that is red will be printed on one screen, every blue item on another screen, and so on. From there, it's traditional screenprinting, infusing layers of color, images, and text together until I have a finished print.

ABOUT THE ARTIST

Patrick Edgeley was working as a graphic designer when a 12-week class at a local art college got him hooked on screenprinting. A few friends liked his work, so he started selling his prints at Brighton Artists' Open House Festival. Now he divides his time between his studio and his print workshop, both based on the south coast of England.

Patrick creates limited-edition prints that have a retro, typographical feel to them. His love of Americana can be seen in his work, and he has been largely influenced by his travels—a few life-changing trips to New York City in particular. He frequently collects images for future prints and draws objects and motifs to be used one day.

www.antigraphic.biz

I LOVE NEW YORK

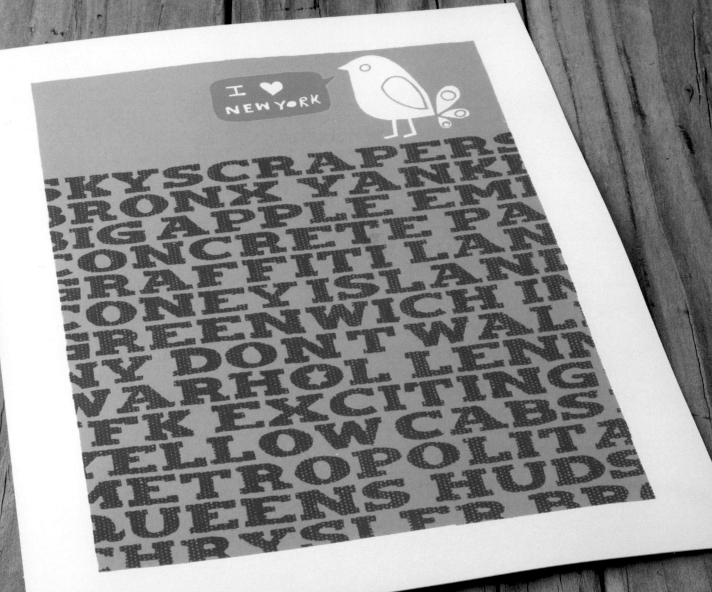

This three-color screenprint uses text in multiple ways—while you may read what the bird's saying first, the text below eventually draws you in. You can use multiple screens or just one screen for all the design elements (see fig. A on page 104). If you do the latter, tape off the elements you're not working on when you print.

What You Do

1. Prepare your screen with emulsion (see Transferring Your Design to the Screen, page 18). Let it dry.

2. Print the I Love New York motifs (three layers) onto transparency film using a computer and printer.

3. Burn the images onto your prepared screen using a UV-exposure unit (see Burning Screens, page 21) (fig. A on the next page).

4. Register the paper to the first image layer on the screen (see Screenprinting Press and Registration, page 26), holding it in place with hinge clamps on your printing table.

What You'll Need

Studio Essentials, page 8

Screenprinting Tool Kit, including one 20 x 24-inch (50.8 x 61-cm) screen, page 16

I Love New York motifs (three layers, see the accompanying CD)

Computer and printer

Paper, 10 x 13 inches (25.4 x 33 cm)

Water-based screenprinting inks: orange, blue, and red

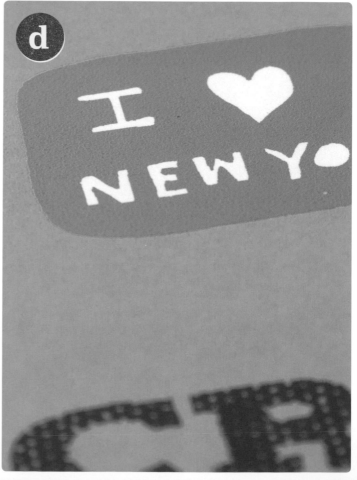

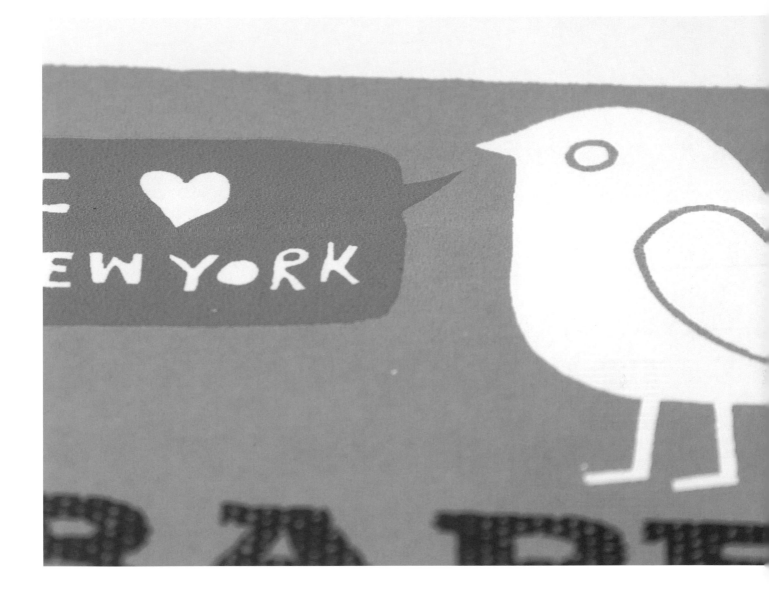

5. Attach low-adhesive screen tape or clear packing tape onto the sections of the screen that you don't want to print.

6. Print the first layer (see Pulling a Print, page 25) by flooding the orange screenprinting ink over the prepared screen, then firmly pulling the color at an 80-degree angle with a squeegee (fig. B). Let it dry.

7. Rinse the orange ink from the screen and let the screen dry.

8. Repeat steps 5–7 for the red text layer (fig. C) and the blue image with text layer (fig. D).

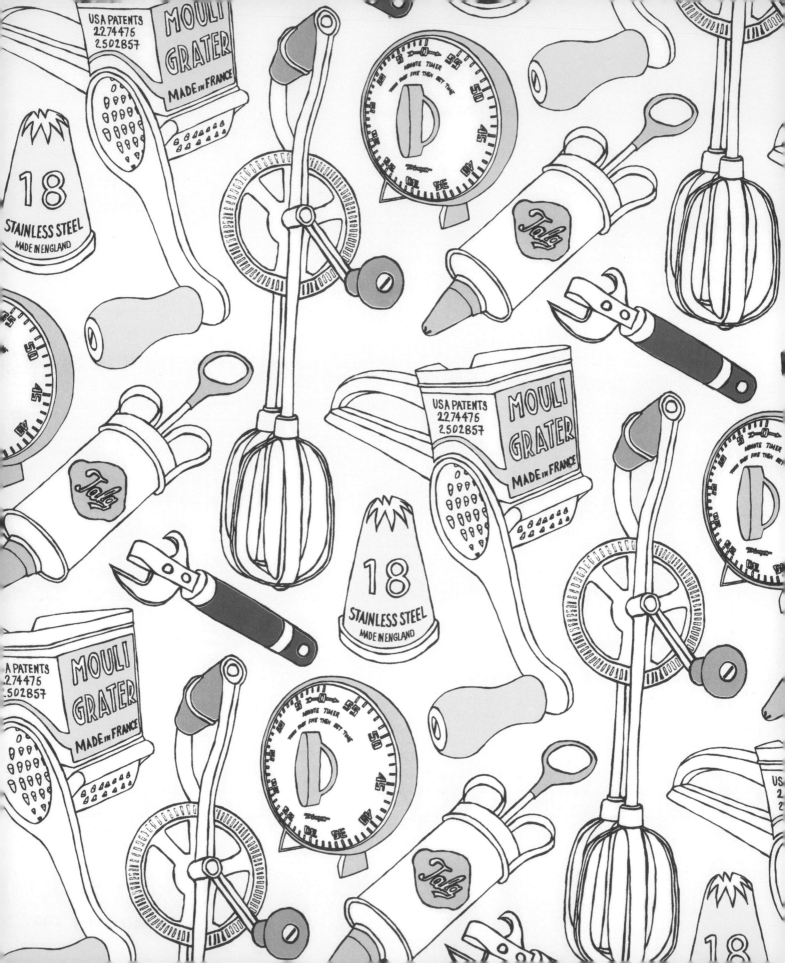

KITCHENALIA PRINT

This multicolor screenprint combines fun images of vintage kitchen appliances and era-appropriate text. The beauty in a print like this is you can make it as simple or as colorful as you'd like—perhaps you'd like to focus on just two main colors, or perhaps you'd like to include seven. To simplify the print, burn only certain images onto the screen—just the cheese graters, for instance, or the can openers. A simplified version printed on a kitchen towel would be the perfect gift.

What You'll Need

Studio Essentials, page 8

Screenprinting Tool Kit,
 including two (or more) 20
 x 24-inch (50.8 x 61-cm)
 screens, page 16

Kitchenalia motifs
 (multiple layers, see the
 accompanying CD)

Computer and printer

White paper, 80 lb., 19½ x 24½
 inches (49.5 x 62.2 cm)

Water-based screenprinting
 inks: yellow, red, blue, green,
 orange, and maroon

What You Do

1. Prepare two (or more) emulsion screens for as many layers as you'd like to print (see Transferring Your Design to the Screen, page 18). Let them dry.

2. Print as many of the Kitchenalia motif layers as you'd like to use onto transparency film using a computer and printer. Since these motif layers measure larger than the 8½ x 11-inch (21.6 x 27.9-cm) transparency film sheets, print them onto multiple pieces of film transparency by using the tile print mode in Photoshop. You can also scale the entire print down to 8½ x 11 inches (21.6 x 27.9 cm).

3. Burn the images onto your prepared screens using a UV-exposure unit (see Burning Screens, page 21) (fig. A on page 109).

4. Register the paper to the background image on the first screen (see Screenprinting Press and Registration, page 26), holding it in place with hinge clamps on your printing table.

CLEANING THE SCREENS

Because there are fine lines in this print, the screens may clog up and blur the lines. Have a bucket of water with clean sponges ready in case you need to clean your screens; this will clear them out and prepare them to print the fine lines again.

5. Print the image (see Pulling a Print, page 25) by flooding the yellow screenprinting ink over the prepared screen, then firmly pulling the color at an 80-degree angle with a squeegee (fig. B). Let it dry (fig. C).

6. Rinse the yellow ink from the screen and let the screen dry.

7. Switch screens and repeat steps 4–6 for the maroon outline layer (fig. D). Rinse the maroon ink from the screen and let the screen dry.

8. Switch screens again and attach low-adhesive tape or clear packing tape onto the sections of the screen that you don't want to print. Repeat steps 4–6 to print layers of color for additional motif elements as desired (fig. E).

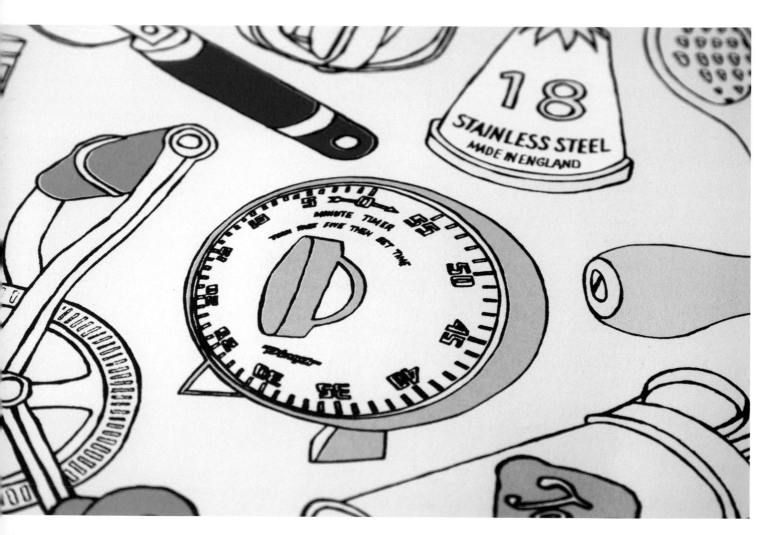

PRINTING ON TRICKY SURFACES

with Kat Jackson

I love screenprinting on paper, but even more than that, I love experimenting with new printing surfaces. I've printed on things such as shirts, shower curtains, and placemats, and each surface definitely has its own challenges and charms. The first tip I could give anyone about printing on new surfaces is always have extra on hand. Figuring out just the right thickness of ink and just the right amount of pressure to pull with is tricky, and definitely a trial-and-error process.

In my art, I gravitate toward simple shapes that are reflective of popular iconography or indie design. These simple motifs print on unusual surfaces particularly well because they are generally repetitive or pattern-based. One simple design repeated over and over on a bag, and you have a popular tote!

Planning with the End in Mind

I always think about the end product before I prepare or burn any screens. I spend plenty of time on my initial sketches, which usually consist of a jumble of motifs in a similar theme—flowers, leaves, woodland creatures, or simple geometric shapes, for example. I then go through the sketches and pull the pieces that I think would work together in a larger composition. Sometimes the entire work will come out in one large drawing, such as a heart made of floral elements. Other times I scan bits and pieces of designs onto the computer to play around with the various elements until I get something that works.

Sometimes my designs are simple and lend themselves best to a small greeting card or journal, while other times I can go wild with size and shape and fill a large poster or T-shirt. Regardless of the size or form of the printed item, I want the overall play of design elements to fit the space well.

Ink Considerations

After coming up with a final design and getting a screen ready to print, the next most thrilling part of the process is mixing up ink colors. I'm amazed by the way slight differences in color can completely change a finished work. Since I tend to print with only one or two colors per design, color choice feels especially important. I like to custom mix the colors I print with, as it gives me more control over the finished hue and makes each piece unique. Just like the imagery, my choice in color changes frequently and is inspired by the time of year, the colors popular in fashion at the moment, or a unique treasure I've just thrifted.

EXPERT TIP

When working with a textured printing surface, take it slow. Screenprinting on new surfaces means that you may have to lift up the screen to check on the ink coverage after a pull or two. Do this slowly to ensure the screen will land back in the same position when you lower it.

The ink consistency is what's really important when printing on any textured surface. Screenprinting ink for fabrics is made to be thinner, so it will spread easier and soak into the fabric more than a basic screenprinting ink would. But I find it cumbersome to divide my time and effort between basic inks and ones specifically made for fabric, so I just buy basic screenprinting ink and then adjust it when I work with any sort of textured background. I generally add one part ink retarder to two parts of my basic screenprinting ink to thin it out a bit. Retarder also slows down the drying time, which helps when I'm trying to repeat the pattern several times on one piece—it ensures the entire piece dries at about the same rate.

Even with the right consistency of ink, it may take several pulls to ensure the design is printed properly, which means it's important that your textured surface doesn't move during the process. I find that clear packing tape helps keep fabric objects in place. I tape down the corners, being sure not to block any of the printing area. I've also seen professional printmakers use shop vacs to secure their textured surfaces. They drill holes in their printing table, place the shop vac underneath, and when it's turned on, it creates a suction effect on the table. Whatever works for you! Don't be afraid to print on unique surfaces—it's just another way to liven up a space or an everyday object.

ABOUT THE ARTIST

When Kat Jackson's husband started his own career in graphic design a few years ago, they began collaborating on some of the drawings that had accumulated in Kat's sketchbook. Her husband helped turn her sketches into digital formats that she could easily manipulate into any color, size, or shape she wanted. This turned into printing cards and small editions of artwork that they eventually sold.

When Kat and her husband started working with a local printmaker to turn those designs into screenprints, she was in heaven. The entire process of printmaking, from the initial sketches, to preparing and burning a screen, to pulling each individual print is one of Kat's favorite ways to spend time. For Kat, not knowing exactly what she's going to end up with, while sometimes frustrating in process, is really half the magic.

www.heartandcrafts.blogspot.com

BIRCH TREE PLACEMATS

These placemats were printed traditionally, with a single color. To cover the entire placemat, as shown here, the birch tree motif needs to be printed twice on each placemat, once on the right side and once on the left. If you'd like to print more than one placemat at a time, print the right sides of all the placemats first using the same registration marks. Then let them dry and print the left sides.

What You Do

1. Prepare your screen with emulsion (see Transferring Your Design to the Screen, page 18). Let it dry.

2. Print the Birch Tree motif onto transparency film using a computer and printer.

3. Burn the image onto your prepared screen using a UV-exposure unit (see Burning Screens, page 21).

What You'll Need

Studio Essentials, page 8

Screenprinting Tool Kit, including one 10 x 14-inch (25.4 x 35.6-cm) screen, page 16

Birch Tree motif (see the accompanying CD)

Computer and printer

Water-based screenprinting ink: white

Natural fiber cotton placemat, 19 x 13 inches (48.3 x 33 cm)

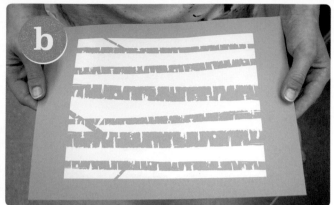

4. Tape off the edges of the screen to ensure ink only passes through the areas that are going to be printed (fig A).

5. Before printing directly onto the placemat, print a test onto a piece of scrap paper by registering the paper to the tree image on the screen (see Screenprinting Press and Registration, page 26), holding it in place with hinge clamps on your printing table. This will help you check alignment and ink levels so you don't worry about making a mistake on a placemat (fig. B).

6. Register the right side of the placemat to the tree image on the screen, holding it in place with hinge clamps on your printing table (fig. C).

7. Print the image (see Pulling a Print, page 25) by flooding white screenprinting ink over the prepared screen, then firmly pulling the color at an 80-degree angle with a squeegee. You may have to pull two or three times to ensure coverage on this textured object. Let dry (fig. D). Repeat for as many placemats as you want to make.

8. Repeat steps 6–7 for the left side of the placemat. When registering the left side, focus on aligning to the right side, but also know that it only adds charm and personality if the two sides don't line up evenly (figs. E and F).

UNIQUE TEXTURE

Since placemats have a more unpredictable texture than paper, the results between two placemats will most likely be slightly different. Knowing that the placemats are not going to line up perfectly or ink consistently may be frustrating at first, but in the end it will make each one unique.

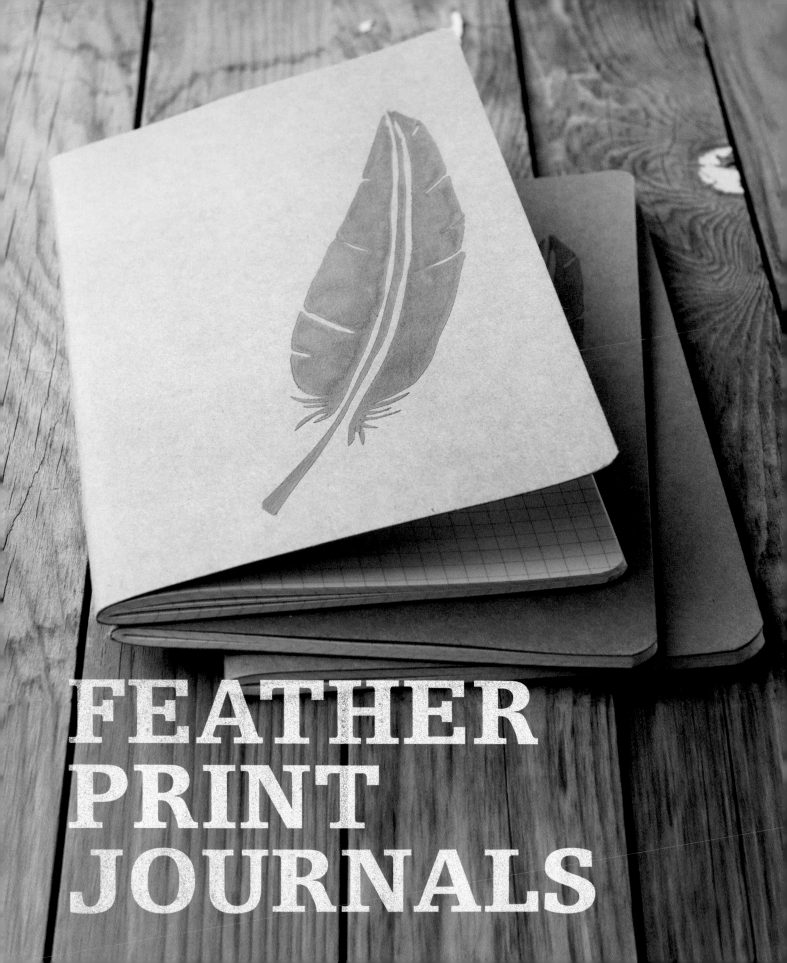

FEATHER
PRINT
JOURNALS

Journals usually have several layers of paper and a stiff cover, but with some practice you'll get used to printing on them. I recommend buying a large pack of inexpensive journals, like the Kraft paper ones shown here, before trying a print on a more expensive journal. Depending on the journal you use, the cover may have a tendency to flip open. Just work slowly and deliberately to ensure that it stays where it needs to. If you decide to use a journal for a print with multiple layers, be extra careful the cover doesn't move as you try to print!

What You'll Need

Studio Essentials, page 8

Screenprinting Tool Kit,
 including one 10 x 14-inch
 (25.4 x 35.6-cm) screen,
 page 16

Feather motif (see the
 accompanying CD)

Computer and printer

Water-based screenrpinting
 ink: gray

Kraft paper-covered journal,
 5 x 8¼ inches (12.7 x 21 cm)

What You Do

1. Prepare your screen with emulsion (see Transferring Your Design to the Screen, page 18). Let it dry.

2. Print the Feather motif onto transparency film using a computer and printer.

3. Burn the image onto your prepared screen using a UV-exposure unit (see Burning Screens, page 21).

4. Before printing directly onto the journal, print a test onto a piece of scrap paper by registering the paper to the stencil on the screen (see Screenprinting Press and Registration, page 26), holding it in place with hinge clamps on your printing table. This will help you check alignment and ink levels before you worry about making a mistake on the journal.

5. Register the journal to the image on the screen, holding it in place with hinge clamps on your printing table.

6. Print the image (see Pulling a Print, page 25) by flooding the gray screenprinting ink over the prepared screen, then firmly pulling the color at an 80-degree angle with a squeegee. You may have to pull two or three times to ensure coverage is adequate. Let it dry.

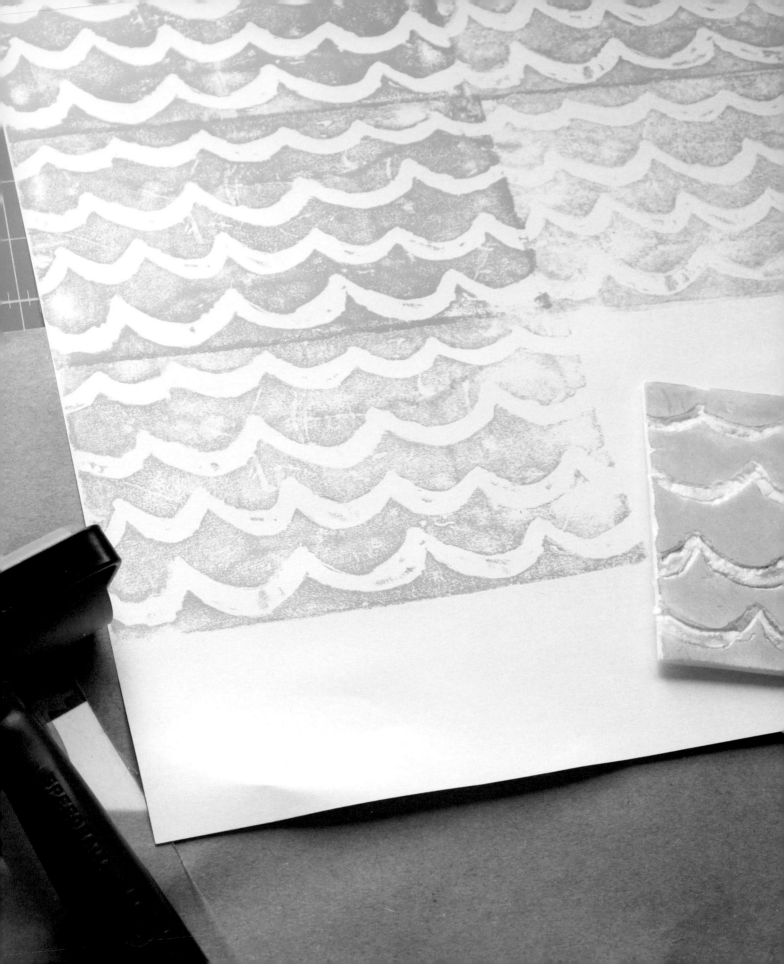

RELIEF PRINTING
with Ruth Bleakley

Printmaking can seem like a daunting field to break into, but I'm here to tell you—don't be afraid to jump right in! In fact, I'm sure you've done more printmaking than you think, in the form of rubber stamps, potato stamps, or even linoleum-block cutting in art class. These are all forms of relief printing, my preferred method of printmaking. Simply put, relief printing is when you apply ink to a three-dimensional object, then "stamp" that object onto your printing substrate. The inked, raised portions of the object create a printed image.

I create everything from hand-printed paper to reusable gift-wrap with relief printing. I often incorporate papers

I've made into my work, especially as endpapers or covers in my bookbinding projects. Because relief printing can be fairly simple, the projects are quick, easy, and perfect for a fun afternoon. One of my favorite ways to relief print is to carve into a Styrofoam plate with a dull pencil to create a stamp. I then apply ink to the raised surfaces on the plate and press the inked portion onto my printing substrate. Because you can print the same image over and over, this method is ideal for creating a series (such as greeting cards or postcards) or a pattern (such as the waves pattern at left).

Printing with Found Objects

Perhaps the most traditional way to relief print is to carve an image into a rubber or linoleum carving block. While this is effective, I find it quicker—and more exciting—to ink up found objects and use them as stamps. I'm constantly experimenting with interestingly textured items that I find around my house or yard to see what they might look like printed. I've tried everything from slicing a bell pepper in half and using it as a stamp, to cutting a dish sponge into a fun shape with scissors and printing with that.

Try slicing a bunch of celery close to the root end, and you'll have a stamp that looks like a rose. Maybe you'd like to make tracks with a plastic animal or dinosaur.

Stamp a leaf, shell, or flower to imitate nature in art. Anything works as long as it's washable, so don't be afraid to make mistakes. Kids love printing with found objects too; you'll be amazed by their creativity when it comes to things they can print with.

A Blast with Bubble Printing

Bubble printing is another one of my favorite printing methods. While not exactly traditional, in that it doesn't use a printing plate or screen, I still consider it printmaking. The surface of the bubble prints the paper

EXPERT TIP

I advise using water-soluble block-printing ink when relief printing—it dries more slowly than acrylic paint, and the water-based formula makes for easier clean-up than the oil-based version. You can probably find a tube for under five dollars at your local art store, or you can use tempera or acrylic paint and a sponge brush. Just make sure to print your image before the paint dries.

with a mixture of watercolor paint and bubble solution. I love that it captures the action of bubbles bursting on the page, and that it's unpredictable. It's a great activity to do with kids, provided you have plenty of room and newspapers laid out. (Bubble mix laden with ink creates what are basically floating ink bombs, so be careful.) You can use bubble mix and watercolor paint to mix bubbles of all different colors and make some really neat wrapping paper or artwork (see page 124).

Once you combine your ink and bubble mixture, it's a matter of dipping the straw into the color, moving over to the area you'd like to print, holding the straw very close to the paper, and blowing gently through the straw to grow a bubble. Carefully removing the straw from the bubble will create the outline you're looking for.

Jump in and Experiment

As far as what you should print on, anything is game! Raid the recycle bin for cereal boxes, then turn them inside out and print a neat gift box. Print on scrap computer paper, then cut out smaller shapes from your prints to glue onto folded cardstock for a handmade card. Cut up an old bed sheet or T-shirt and print a bandana or reusable cloth gift-wrap. If you print on cloth, let it dry thoroughly, then sandwich it between two sheets of scrap paper. Press the back of the design on medium heat (without steam) to set the ink.

Regardless of what you decide to print with and what you decide to print on, don't hold back. Every professional printer began somewhere, by jumping in and trying things out. With these quick and easy printmaking techniques, there is no pressure to do it right the first time.

ABOUT THE ARTIST

A bookbinder by trade, Ruth Bleakley found her way into the art of printing because she is passionate about creating her books entirely by hand. Putting her own colorful, whimsical spin on the papers—and particularly the covers—that make up her books allows her to breathe even more art and life into the beautiful and ancient craft of bookmaking.

Ruth also creates handmade journals and stationery, and she enjoys using printmaking techniques to create her own decorative paper for gift-wrap and cards. She is drawn to relief printing because the basic supplies are readily available in her home—a perk of printing with mostly found objects—and the variety of results she encounters by working with non-traditional printing methods keeps her surprised.

www.ruthbleakley.com

BUBBLE
WRAPPING PAPER

Creating bubble prints is an unusual form of printmaking. If you think of each bubble as the "plate" that holds the ink, the fact that the bubble can only imprint once makes it a sort of monotype print. Alternatively, it could be considered a type of paper marbling. Blue bubbles printed on this brown paper grocery bag create charming wrapping paper.

What You'll Need

Studio Essentials, page 8

Brown paper grocery bag

Iron (optional)

Bottled bubble mix

Blue watercolor paint

Small paper cup

Craft stick

Straw

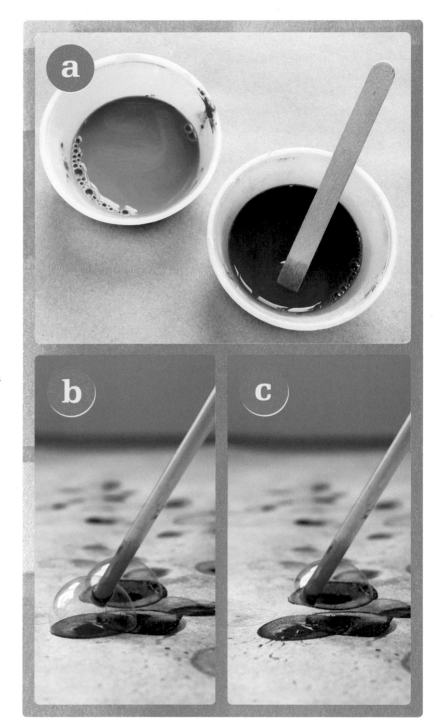

What You Do

1. Cut the grocery bag open and lay it down on a flat surface, printed side down. If it won't lie flat, iron it on high heat without steam.

2. Prepare the "ink." Measure two tablespoons of bottled bubble mix into a small paper cup, then squeeze a pea-size amount of watercolor paint into the mix. Stir with a craft stick until it's fully dissolved. Adjust the strength of the color by adding more paint if necessary (fig. A).

3. Dip the straw into the color mixture. Carefully suck up a tiny bit of the mixture into the straw and tap off any extra drips.

4. Move the straw over to the brown paper bag and, holding the straw very close to the paper, blow gently through the straw. The goal is to start the bubble "growing" on the paper (fig. B).

5. Carefully remove the straw from the bubble and watch the bubble pop. The longer the bubble stays on the paper without popping, the stronger the "outline" of the bubble will be (fig. C).

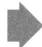

PLAYFUL EXPERIMENTATION

Create interesting patterns by blowing bubbles that touch one another. For more action-packed bubble bursts, experiment with blowing air through the straw.

SCALLOP SHELL GIFT WRAP

A tradition in Japan, *furoshiki* is a wrapping cloth used to cover everything from lunch boxes to gifts and groceries. This one is printed with shells—an example of relief printing with found objects. Before starting, find a shell from the beach or your local craft or dollar store.

What You Do

1. Position your cloth on top of the foam or sponge where you'd like to make a print. The sponge underneath the cloth will allow the shell to come in contact with more of the fabric as you push down (fig. A).

2. Paint a thin coat of purple water-based block-printing ink onto the shell with a foam brush (fig. B on next page).

What You'll Need

Studio Essentials, page 8

Large square of fabric

Scallop shell that's fairly flat

Piece of soft foam or sponge
 slightly larger than the shell

Water-based block-printing ink:
 purple and turquoise

Foam brush

Iron

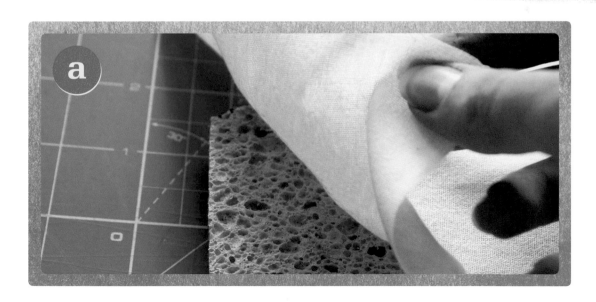

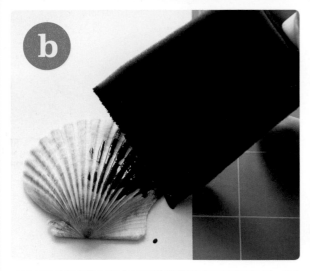

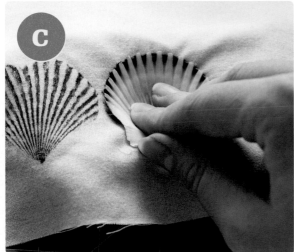

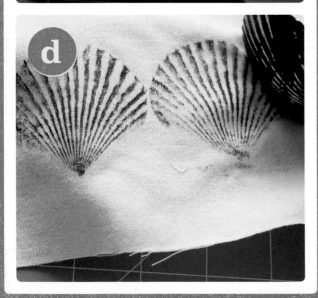

3. Carefully press down the painted side of the shell into the fabric so it sinks into the foam. Hold it firmly so the ink does not blur as you press (fig. C).

4. Lift the shell slowly off the fabric (fig. D).

5. Continue applying ink as necessary to print a whole row of purple shells. Move the sponge underneath the fabric as you move the shell down the line.

6. Rinse the shell in clean water and let it dry. For the second row, apply a thin coat of turquoise water-based block-printing ink onto the shell with a foam brush, and print a row of blue shells above the row of purple shells.

7. Continue to alternate colors by row until the fabric square is covered. Let it dry, and then iron the back side of the fabric without steam to set the ink (see Curing a Fabric Print, page 25).

STYROFOAM PRINTED PAPER

This project utilizes traditional relief-printing methods, but instead of carving into a rubber or linoleum block, you'll carve into a Styrofoam plate. It's a softer material to work with than the traditional blocks, so all you need for carving is a dull No. 2 pencil.

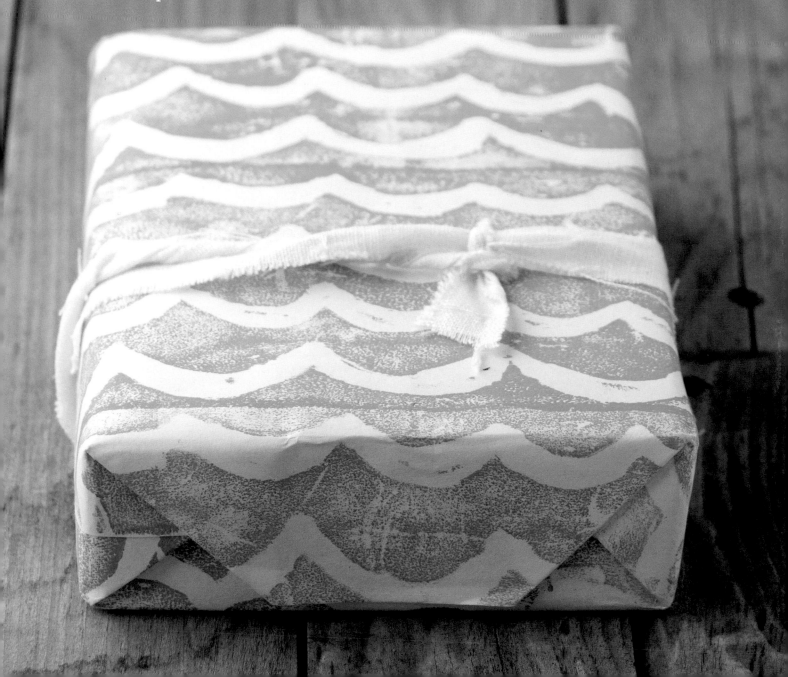

What You'll Need

Studio Essentials, page 8

Relief-Printing Tool Kit, page 29

Styrofoam meat tray, washed

One sharp No. 2 pencil

One dull No. 2 pencil

Water-based block-printing ink: blue

Paper

Iron

Scrap piece of newsprint

What You Do

1. Cut off the edges of the Styrofoam plate so it lies flat. Use a sharp No. 2 pencil to draw a wave design or a design of your own on the plate. Remember that the print will be the opposite of what you're drawing—the areas you draw and carve out with the pencil will be white in the end.

2. Use your dull pencil to press down any areas in your design that you want to be white. You don't need to completely remove these sections; they just need to be pushed down far enough so that ink won't touch them (fig. A).

3. Squeeze a small amount of blue water-based block-printing ink onto a small glass plate. Roll a rubber brayer through the ink to distribute it evenly over the plate, then roll the brayer back and forth until it is evenly coated with a thin layer of ink.

4. Gently roll the ink onto the Styrofoam plate until the raised portions are evenly covered (fig. B).

5. Make the print by placing the Styrofoam plate, ink side down, on the paper. Rub firmly but gently with the heel of your hand to make a print (fig. C).

6. Lift the Styrofoam to check your print. Re-ink your roller, and keep printing until the paper is covered. You may need to add more ink to your glass plate after a few prints.

7. Allow your printed paper to dry. If you need to flatten the paper, press it on medium heat without steam, with a scrap piece of newsprint between the iron and the printed paper. (Sometimes the ink makes the paper curl.)

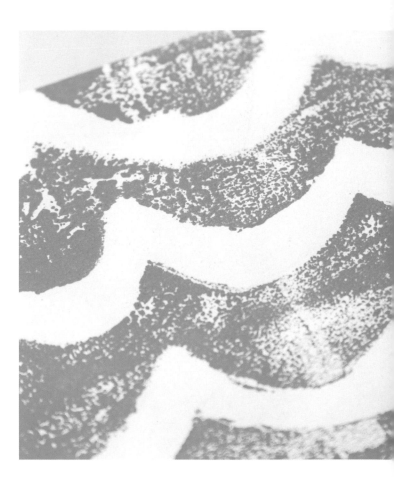

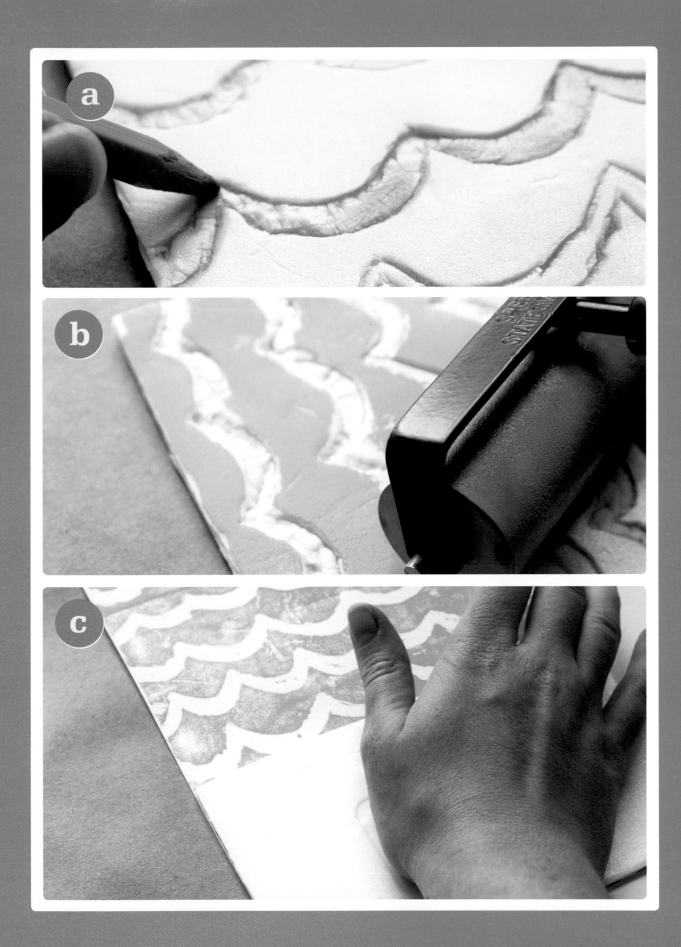

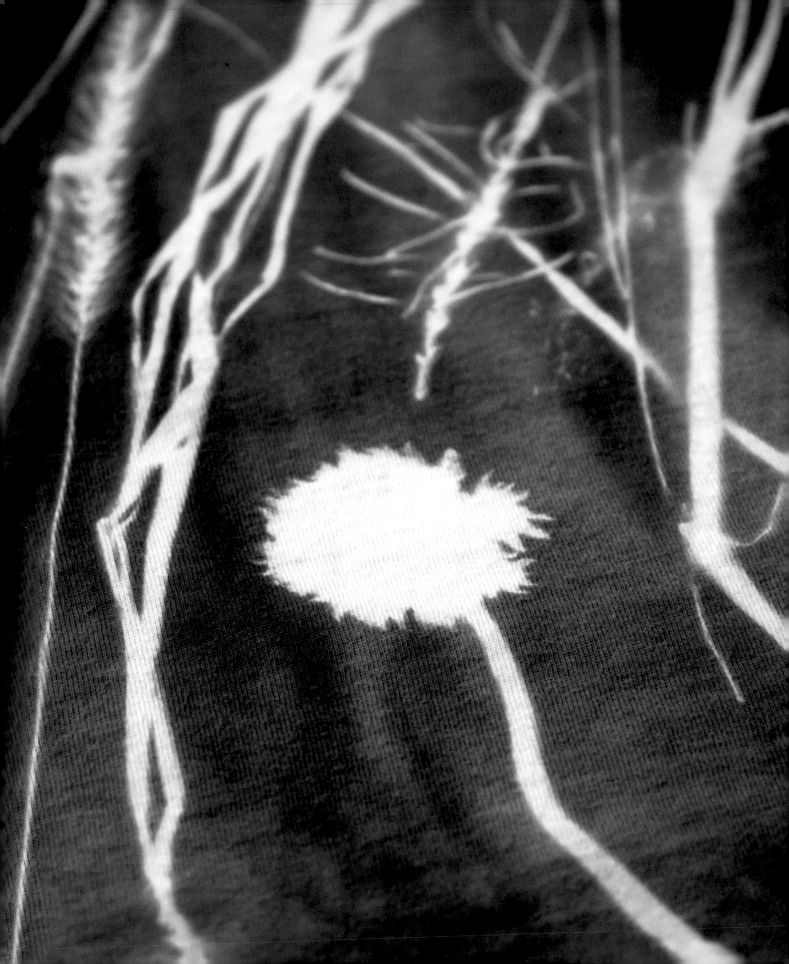

CYANOTYPE PRINTING
with Matt Shapoff

Cyanotype printing involves placing found objects, transparency film, or photo negatives onto a chemically sensitized printing surface, then laying the printing surface in the sun, where the UV-light reacts with the chemicals on the paper to create a blue hue. The places on the printing surface not exposed to the sunlight—where the printing surface was covered by the objects or negative—wash out to the base color of the substrate because the chemicals did not have anything to react with. The result is a Prussian blue print that is visually stunning.

The process begins to sound a little more complicated when you consider the chemicals that are used to sensitize the paper in the first place. Ferric ammonium citrate (a green powder) and potassium ferricyanide (a red powder) are mixed with water, and then with each other, to create the final cyanotype solution that is applied to the printing surface. For the beginner, however, there are many options to make the chemical-mixing process easier. For example, you can buy cyanotype sensitizer, which has pre-measured amounts of the required chemicals for more straightforward mixing. Or you could go one step further and buy a basic solar print kit, which includes a piece of already sensitized paper so you don't have to worry about any chemicals at all. There is also a product called Inkodye by Lumi, which uses a different ink mixture. Inkodye reacts to UV-light in a similar manner, so you can learn the process without mixing any chemicals. You can also buy pre-treated cyanotype sheets at some hobby stores or online.

Experimenting with Variables

Lighting plays a key part in cyanotype printing. I try as hard as I can to be as meticulous as possible, but if a cloud comes over where I'm working, the results are going to change. I live in Long Island, where sunlight bounces off of three different bodies of water near my house—a pond, the bay, and a canal—to create an incredible quality of light. If I did my same process in say, Arizona, the color would show up differently in the end. Because cyanotype printing relies on the sun, you have to experiment with the sun and light wherever you're working. Even the time of day you print will alter the results.

Another variable I like to experiment with is the water I use to mix the chemicals. If I need a project to be as predictable as possible, I use distilled water. However, if I'm in the mood to experiment, I use local water from my garden hose, or even salt water. The natural process lends itself to experimentation, especially once you have the basic process down. If you're just starting out, however, use distilled water at room temperature, about 70° F.

I typically print on Rives BFK watercolor paper, a luxurious, absorbent paper that stays wet for a long time. I also enjoy working with textiles, whether it's a batch of scarves or a zip-up sweatshirt. If I'm making multiple items and I'd like them to look fairly similar when I'm finished, I do them all in one day at roughly the same time so they receive a pretty consistent amount of light—and I always make extra, because there are bound to be some in a batch that the light doesn't hit quite like the rest.

 EXPERT TIP

If you're just starting out—either with the process in general or with printing in a new location—the best way to understand how the sun will work is to do a few test prints. Do one test print first thing in the morning, one at midday, and one later in the afternoon. You'll be able to tell pretty quickly which time of the day works best in your area.

 # A HISTORY OF CYANOTYPE

Cyanotype printing is the precursor to traditional photography; its discovery in 1842 marked the first time in history that an object was copied onto a piece of paper. Sir John Herschel discovered the process, but Anna Atkins was the first person to use cyanotype printing commercially when she printed a book of cyanotype botanical prints. She traveled with her father, a botanist, who would sketch new plants he came across; she began using the cyanotype process to record plant findings instead of having to sketch them. Atkins published her first prints in *Photographs of British Algae: Cyanotype Impressions* in 1843.

Scientific and Visceral

Cyanotype printing is both a scientific and a visceral experience. I mix chemicals and pay attention to ratios, but in the same vein, I measure those ratios simply: I mix a scoop of potassium ferricyanide with water and half of a scoop of ferric ammonium citrate with water to begin the process. Of course this ability to feel the right ratios comes after decades of working with the materials, so I suggest that beginners look for cyanotype sensitizer. The combination of this natural, artistic feel and a fairly scientific process has always appealed to me, as I spent many years thinking I had a technical, scientific mind, and that my artistic side was just a hobby. What a joy and relief to have found a way to combine the two sides.

ABOUT THE ARTIST

Matt Shapoff was an engineering student when the chair of the photo department at NYU noticed he had an eye for photography. A switch of majors, and Matt knew he was in the right place. He used his engineering knowledge to figure out unique ways to shoot— from rollerblading while photographing to shooting from the hip without looking through the lens. One semester, he elected to take an alternative processes class, which is where he first experienced cyanotype printing.

Years later, and he's still experimenting with the method. The chemistry of it fascinates him, as do the variables involved, from the sun to the type of water he uses to mix the chemicals. His work is a constant movement to keep this art process alive.

www.handmadeonpeconicbay. blogspot.com

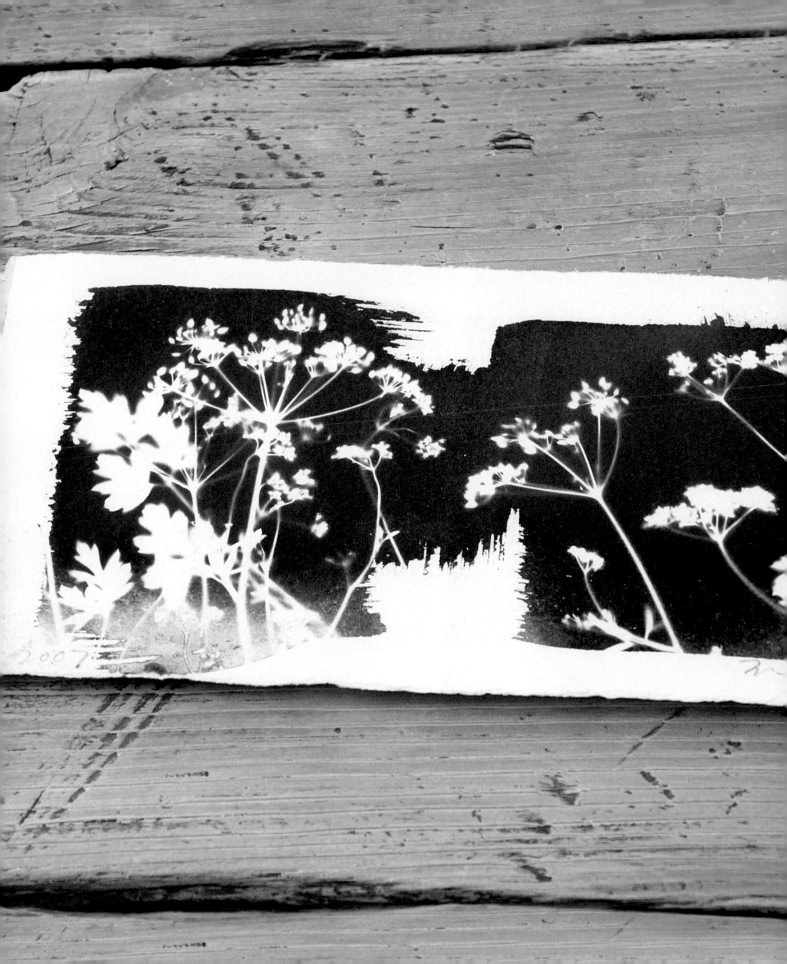

BOTANICALS ON PAPER

For this print, botanicals are placed directly onto watercolor paper. Any flowers, leaves, rocks, feathers, or sticks will do. You can also work with transparency film in place of the botanicals; the process is the same either way. Motifs of beautiful botanicals are included on the accompanying CD, or you can print your own images onto transparency film.

What You Do

1. Wearing a dust mask and rubber gloves, mix together the cyanotype sensitizer in a dark room, following the instructions provided by the manufacturer. Work quickly, as the sensitizer will only be active for approximately two hours—this may vary slightly depending on the specific sensitizer that is used (fig. A on next page).

2. Paint the mixture onto watercolor paper using a paintbrush. This should also be done in a dark (or very dimly lit) room to avoid exposing your print prematurely. Leave the coated paper in a dark room to dry thoroughly (fig. B on next page).

What You'll Need

Studio Essentials, page 8

Cyanotype Tool Kit, page 33

Botanical motifs (see the accompanying CD) or flowers, leaves, feathers, and sticks (if you're not using the motifs)

Computer and printer

Watercolor paper

3. If you'd like to use the botanical motifs on the accompanying CD, print them onto transparency film using a computer and printer.

4. Place the coated paper onto the piece of wood, then arrange the botanicals or transparency film on top of it.

5. Set the glass sheet on top of the elements and the paper.

6. Place the sandwiched paper in direct sunlight. The exposure time will vary depending on the strength of the light. When the visible portions of the paper have darkened to a brownish-green color, the exposure is complete.

7. Rinse your print in cold water to remove the excess sensitizer and prevent the white, unexposed areas from turning blue. Agitate the print continuously for approximately five minutes, or until the water runs clear.

8. Make a "clothesline" with string and hang your print to dry, using clothespins to attach it to the string.

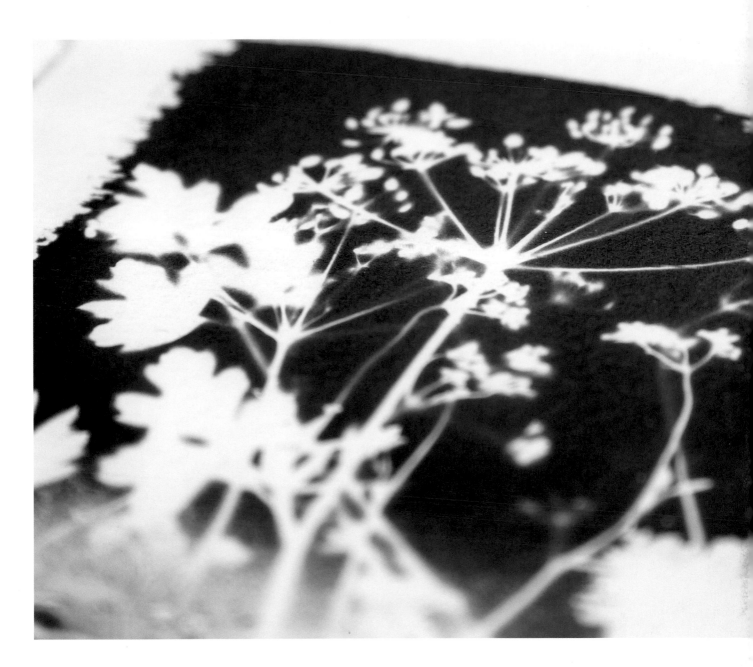

 ## TURNING IT BLUE

Keep in mind that anywhere you paint the mixture will end up blue, so if you'd like to leave the edges or certain spots white, avoid those areas with the mixture.

CYANOTYPE SHIRT

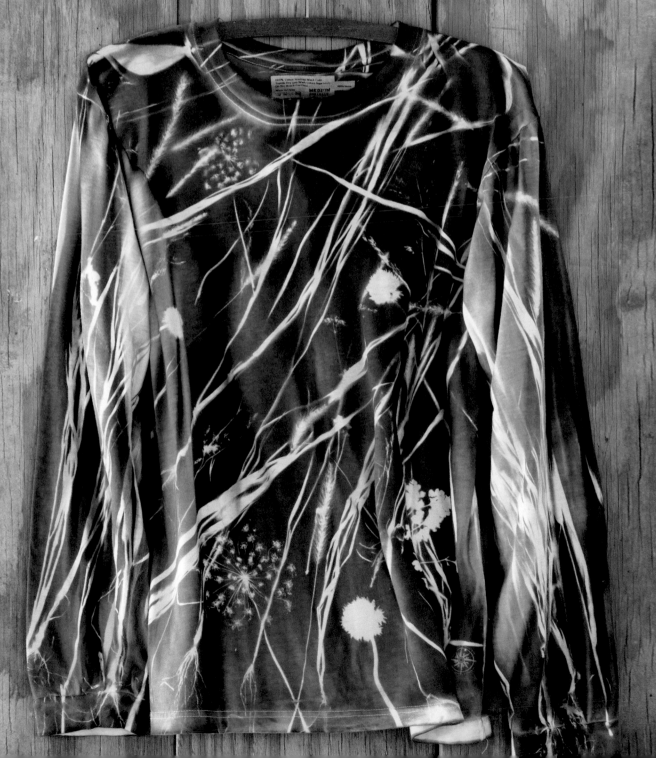

For this print, botanicals are placed directly onto a cotton T-shirt. As with the botanical print on watercolor paper, any flowers, leaves, or sticks will do, or you can use transparency film with your own image or motifs from the accompanying CD. Because of the natural folds in fabric as it hangs, there may be darker blue areas and areas that are more white; this inconsistency adds to the natural beauty of the piece, so embrace it.

What You'll Need

Studio Essentials, page 8

Cyanotype Tool Kit, page 33

Botanical motifs (see the accompanying CD, optional)

Flowers, leaves, and sticks (if you're not using the motifs)

Computer and printer

Cotton long-sleeved T-shirt

What You Do

1. Wearing a dust mask and rubber gloves, mix together the cyanotype sensitizer in a dark room, following the instructions provided by the manufacturer. Work quickly, as the sensitizer will only be active for approximately two hours (this may vary slightly depending on the specific sensitizer that is used).

2. Heavily coat the front side of the T-shirt with the mixture using a paintbrush. This should also be done in a dark (or very dimly lit) room to avoid exposing your print prematurely.

3. Leave the coated shirt in a dark room to dry thoroughly.

4. If you'd like to use the botanical motifs on the accompanying CD, print them onto transparency film using a computer.

5. Place the coated shirt onto the piece of wood, then arrange the botanicals or transparency film on top of it.

6. Set the glass sheet on top of the elements and the shirt.

7. Place the sandwiched shirt in direct sunlight. The exposure time will vary depending on the strength of the light. When the visible portions of the material have darkened to a brownish-green color, the exposure is complete.

8. Rinse your shirt in cold water to remove the excess sensitizer and prevent the white, unexposed areas from turning blue. Agitate the shirt continuously for approximately 5 minutes, or until the water runs clear.

9. Make a "clothesline" with string and hang your shirt to dry, using clothespins to attach it to the string.

10. Repeat steps 2–9 for the back side of the shirt.

RESOURCES

Screenprinting Supplies

DANIEL SMITH, FINEST QUALITY ARTISTS' MATERIALS
800-426-6740
www.danielsmith.com

DHARMA TRADING CO.
800-542-5227
www.dharmatrading.com
Specializes in printing on fabric; blank T-shirts, inks for screenprinting, starter kits, and more. Check out Jacquard Professional Screenprinting Inks.

DICK BLICK
800-933-2542
www.dickblick.com
Screenprinting kits, inks, carving blocks and tools for relief printing, exposure units, heat transfer presses, and other supplies, as well as high-quality papers.

GOLD-UP
510-887-6987
www.goldupusa.com
Screens and frames, screenprinting film, squeegees, and more.

RYONET CORPORATION
www.ryonet.com
Kits, transfer papers, blank T-shirts, software, clip art, and more.

SILKSCREENING SUPPLIES
800-314-6390
www.silkscreeningsupplies.com
Offers a wide range of supplies, equipment and kits for beginners, hobbyists, and small business start-ups.

SPEEDBALL
800-898-7224
www.speedballart.com
Screenprinting and block-printing inks, carving blocks and tools for relief printing, fabric inks, emulsions, hinge clamps, kits, mediums, printing screens, photo-flood bulbs, squeegees, and more.

TEXSOURCE
888-344-4657
www.texsourceonline.com
Wide range of screenprinting supplies, including inks, emulsions, and exposure units.

Screenprinting Press

DIY TEE SHIRTS
www.diyteeshirts.com
PDF instructions and videos on how to build your own screenprinting press.

EMILY OWEN
www.emilyowenartist.wordpress.com
Blog post with free tutorial on how to build a one-color screenprinting press. http://emilyowenartist. wordpress.com/2011/06/11/ how-to-build-a-one-color-screenprinting-press/

PRINTING PLANS
www.printingplans.com
Offers a free plan on how to build a four-color T-shirt screenprinting press.

SCREENPRINTING FOR PROFIT
www.screenprintingforprofit.com
DVDs with tutorials on how to build a screenprinting press.

SILKSCREENING SUPPLIES
800-314-6390
www.silkscreeningsupplies.com
Offers a variety of screenprinting presses in all price ranges. For beginners, hobbyists, and small business start-ups.

Printmaking Supplies

ART SUPPLY
800-937-4278
www.artsupply.com

DICK BLICK
800-933-2542
www.dickblick.com

DANIEL SMITH
800-426-6740
www.danielsmith.com

JERRY'S ARTARAMA
800-827-8478
www.jerrysartarama.com

MCCLAIN'S PRINTMAKING SUPPLIES
800-832-4264
www.imcclains.com

TAKACH PRESS
800-248-3460
www.takachpress.com

Paper Sources

DANIEL SMITH, FINEST QUALITY ARTISTS' MATERIALS
800-426-6740
www.danielsmith.com

DICK BLICK
800-933-2542
www.dickblick.com

NEENAH PAPER
800-994-5993
www.neenahpaper.com

THE PAPER MILL STORE
800-790-8767
www.thepapermillstore.com

PAPER-PAPERS
888-326-8866
www.paper-papers.com

Cyanotype

BLUEPRINTS ON FABRIC
800-631-3369
www.blueprintsonfabric.com
Cyanotype chemicals and a range of fabrics that are hand treated and ready to print.

BOSTICK & SULLIVAN
505-474-0890
www.bostick-sullivan.com
Cyanotype kits.

CYANOTYPE STORE
800-894-9410
www.bluesunprints.com
Kits, chemicals, and treated fabrics.

FREESTYLE PHOTOGRAPHIC SUPPLIES
www.freestylephoto.biz
Cyanotype kits.

editor: **THOM O'HEARN**
art director: **KRISTI PFEFFER**
graphic designer: **RAQUEL JOYA**
photographers: **CYNTHIA SHAFFER, LAILA SMITH**
cover designer: **KRISTI PFEFFER**
writers: **AMANDA CRABTREE WESTON, SARAH MEEHAN**
copyeditor: **NANCY D. WOOD**
assistant editors: **KERRI WINTERSTEIN, MONICA MOUET, DEREK PORCELLA**
model: **CAMERON SHAFFER**

ABOUT THE CD

The CD containing all of the motifs for the projects in this book can be found in the sleeve attached to the inside back cover. In addition to the project motifs, the contributing artists have provided additional motifs for you to use, so that you can mix and match, or make completely new projects. The written instructions, photographs, designs, patterns, motifs, and projects in this volume are intended for the personal use of the reader and may be reproduced for that purpose only. Any other use, especially commercial use, is forbidden under law without written permission of the copyright holder.

INDEX

ABOUT THE AUTHOR

Jenny Doh is founder and head of *www.crescendoh.com*. She has authored and packaged numerous books including *Crochet Love, Craft-a-Doodle, Creative Lettering, Stamp It!, Journal It!, We Make Dolls!, Hand in Hand,* and *Signature Styles*. She lives in Santa Ana, California, where she loves to create, stay fit, and play music.